AVAILABLE LIGHT PHOTOGRAPHY

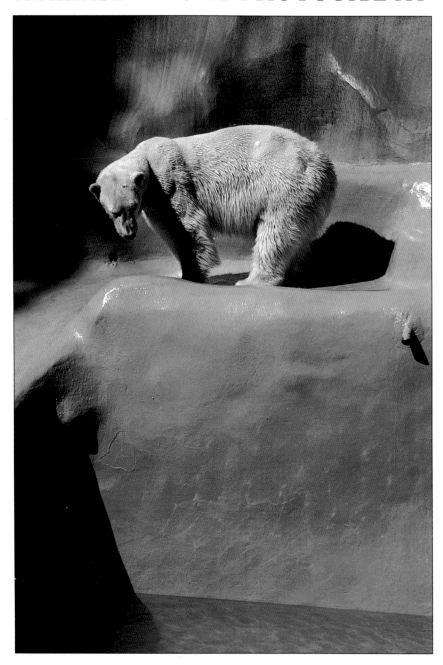

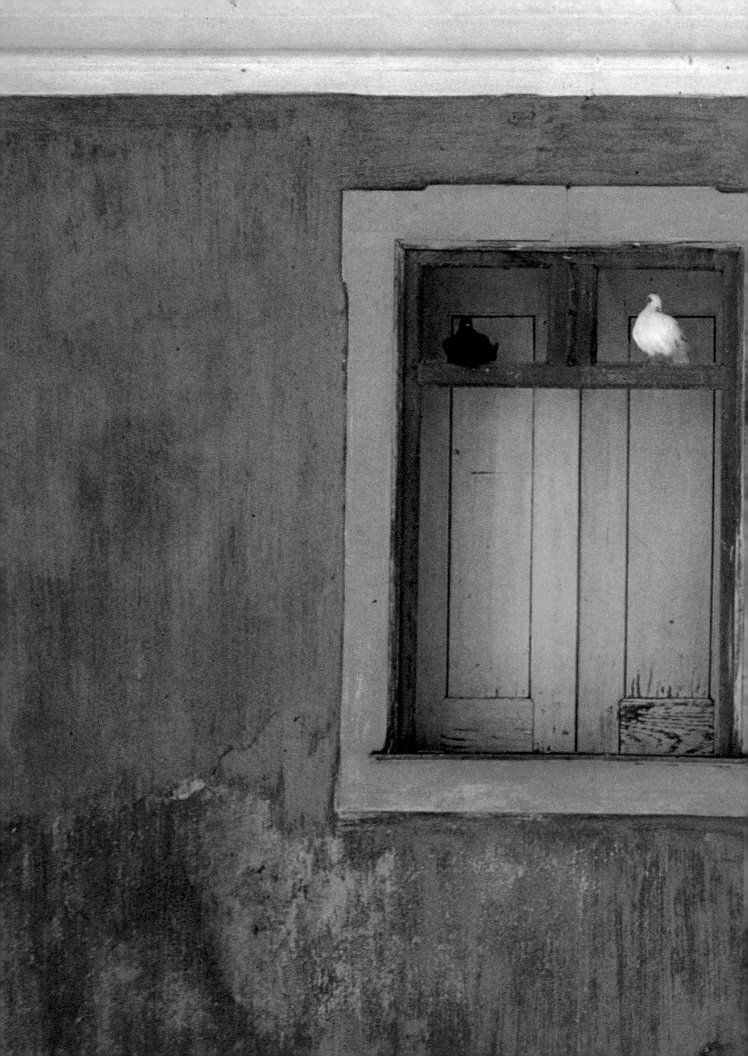

AVAILABLE LIGHT PHOTOGRAPHY

LOU JACOBS, JR.

AMPHOTO
AN IMPRINT OF WATSON-GUPTILL PUBLICATIONS
NEW YORK

To my wife, Kathy

The photograph on the preceding two pages was
made by Jay Maisel, and the photographs on the next
two pages were made by Will & Deni McIntyre.

Each of the photographs appearing in this book is
copyrighted in the name of the individual photographers.
The rights remain in their possession. All photographs
not otherwise credited are copyrighted by the author.

Copyright © 1991 by Lou Jacobs, Jr.
First published in 1991 in New York by AMPHOTO,
an imprint of Watson-Guptill Publications,
a division of BPI Communications, Inc.,
1515 Broadway, New York, NY 10036.

Library of Congress Cataloging-in-Publication Data
Jacobs, Lou.
 Available Light Photography / Lou Jacobs, Jr.
 Includes index.
 ISBN 0-8174-3548-4 ISBN 0-8174-3459-2 (pbk.)
 1. Photography, Available Light. I. Title.
TR590.J24 1991
778.7'6— dc20

Manufactured in Singapore
3 4 5 6 7 8 9 / 99 98 97 96 95 94

Editorial concept by Robin Simmen
Edited by Rick Conant
Designed by Jay Anning
Graphic production by Ellen Greene

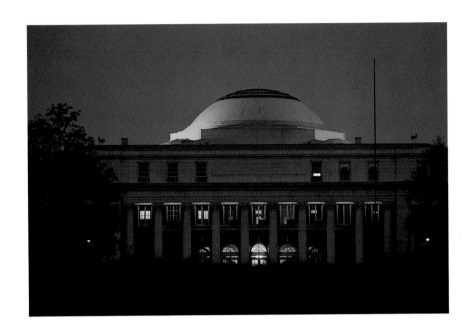

Sincere thanks to these individuals and companies who loaned me photographs to enrich the content and appearance of this book: Lewis Portnoy, Jay Maisel, Eduardo Fuss, Will & Deni McIntyre, Derald E. Martin, Tom Atwood, Ray (Bud) Kennedy, James Cook, Bernard Lynch, Bill Stahl, Scott Mutter, Sonja Bullaty, Angelo Lomeo, Terry Pagos, Kathleen Jaeger, Kay Chernush, Grant Heilman, Jim Jacobs, Jim Nikus III, Krystal Kimp, Eastman Kodak Company, and Fuji Photo Film, U.S.A.

CONTENTS

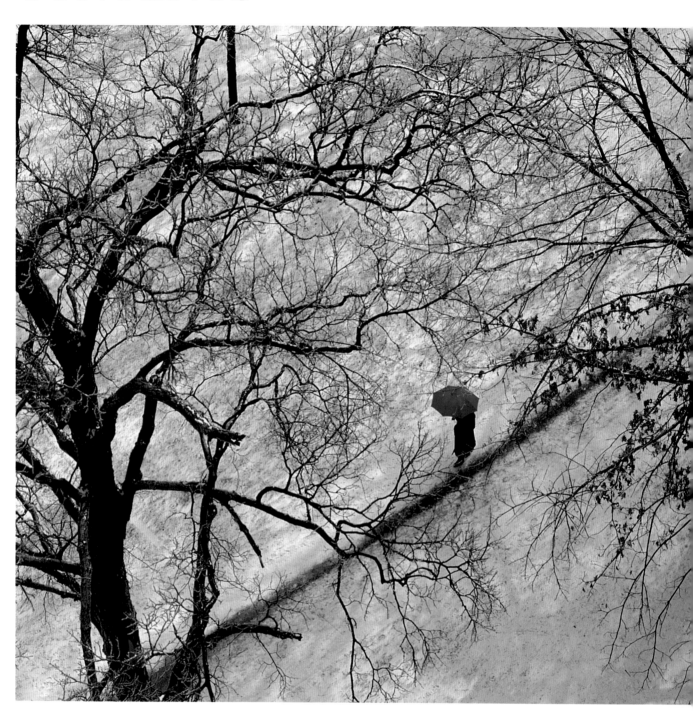

INTRODUCTION

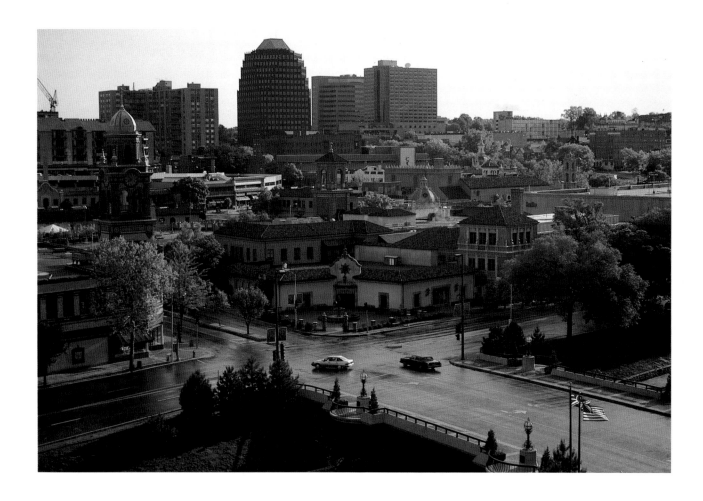

"Light is the most important person in the picture."
–Claude Monet

Until the end of the 19th century the only light that painters and photographers had to work with was the natural light of day, outdoors and indoors, rain or shine. In their studios they used window light and skylights and produced some beautiful effects, as in the work of Rembrandt, Franz Hals, and Julia Margaret Cameron. Although oil lamps and candles were available, the films produced during the 1800s were so slow that these light sources were basically useless for photography.

Then in 1865, John Traill Taylor mixed magnesium and another powder to produce a flash of "extreme brightness." Thomas Edison's first commercial incandescent lamp was brought out in 1879, but photoflood lamps and quartz lights were still decades away. In 1883 G.A. Kenyon introduced a magnesium flash powder that didn't have the stench of the previous attempts, and for the next 37 years, a series of improvements appeared, such as smoke-free devices and flash cartridges.

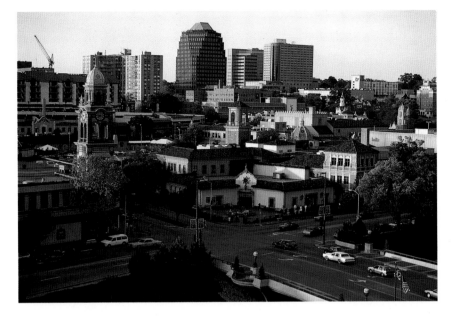

Changing light makes a section of Kansas City, Missouri, change its appearance and mood throughout the day. On the far left, the sun has just come up; the next picture shows the late-afternoon glow, and the one below was made later at night with the city's lights glowing in the darkness. In your photographic experiments, try to give yourself the opportunity to shoot one outdoor situation all day and into the night; the mood of the images could be quite revealing.

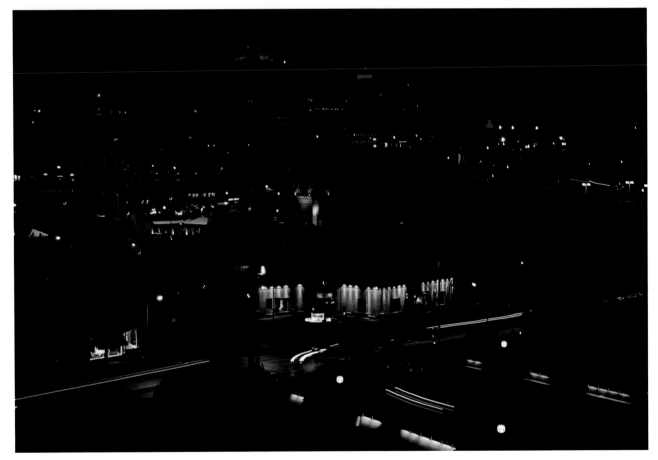

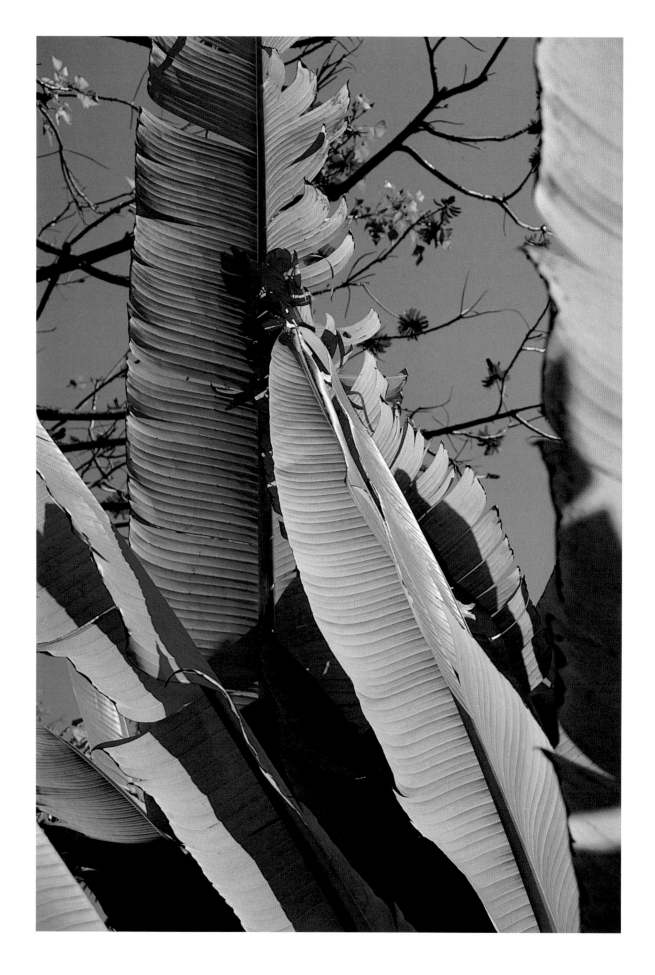

Early in the 20th century, photographers were still using the smoky flash powder, and it was not until 1925 that the flashbulb was invented. In the 1940s electronic flash units were heavy and cumbersome. Now they have shrunk to about the size of a postage stamp and are built into just about every type of camera. Today, flash photography is so easy and popular that some photographers never experience the pleasure of working with available light. Still, photographers at all levels are taking millions of pictures using variations of daylight and existing light. This book explores the many reasons why available light photography is challenging and rewarding. Shooting with flash is convenient and necessary, but you'll often find more spontaneous expressions and beautiful lighting with natural light.

This book is full of visual ideas to help you get the most from shooting with existing light. I hope to encourage you to see better without using flash and to uncover moods and effects with only the light around you. Many of the photographs and illustrations shown are examples of what you can shoot without any tricks or unusual equipment. Opportunities to make such pictures are endless if you're resourceful. If using flash has become a habit, you can look forward to capturing images without it that you never imagined possible.

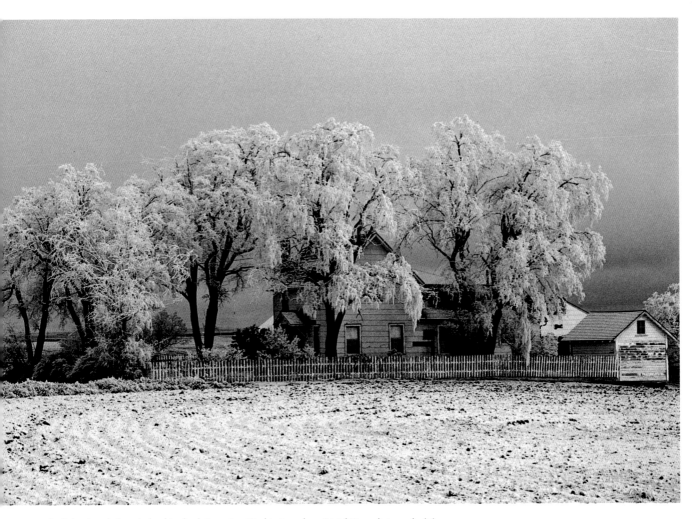

Sunlight glowed through the thin clouds in eastern Washington where Kristal Kimp photographed the snow-laden trees against a distant gray sky. Although the lighting is not direct or bright, the image is still crisp and saturated with color. Kristal used an autofocus SLR with a 35-80mm zoom lens and Kodachrome 64.

Backlighting glamorizes the highlighted leaves of a palm tree. Tiny spots of colored flowers show in the background and strong shadows add to the impact of the picture. I used Kodachrome 64 and a 70-150mm zoom lens, although numerous films and lenses close to that range could have been used.

INTRODUCTION

YOU'VE ALREADY STARTED

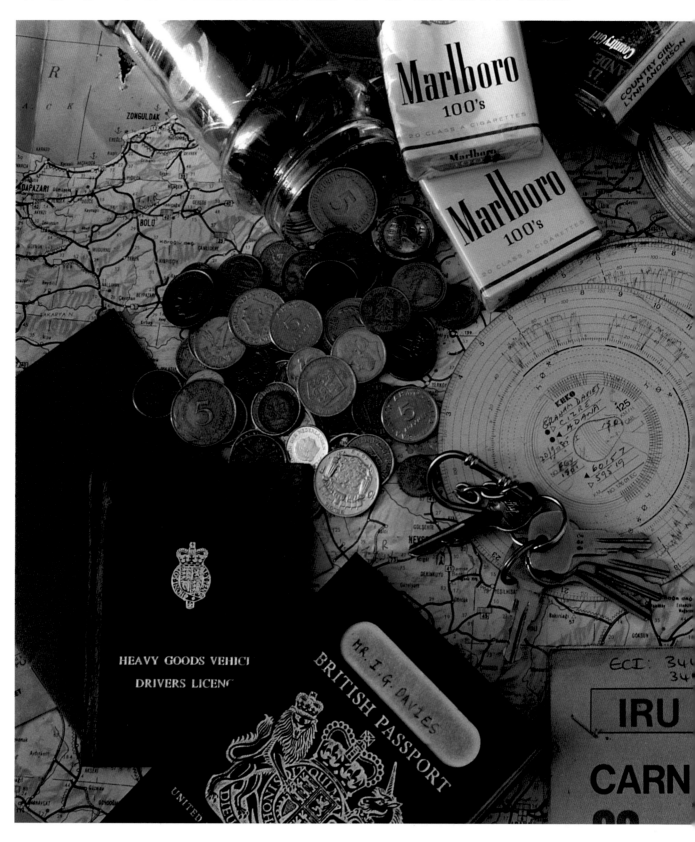

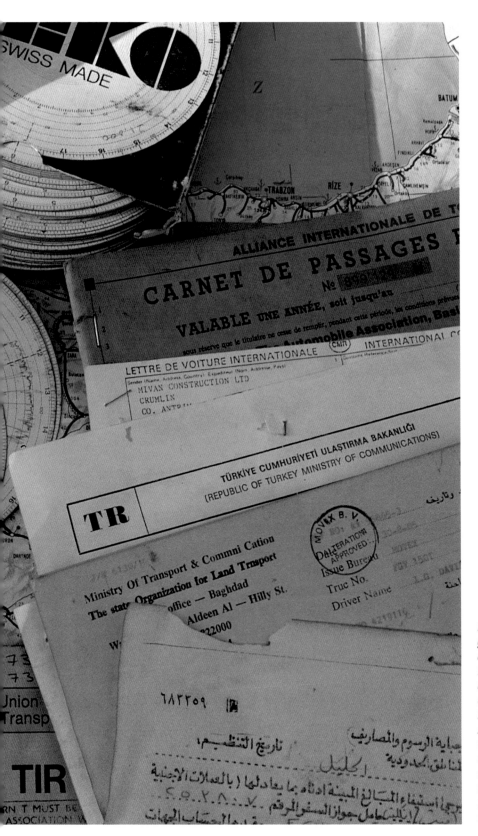

In 1986, photojournalist Kay Chernush undertook a grueling assignment accompanying a 15-ton truck and its driver 3,800 miles from England to Baghdad, Iraq in 18 days. She had to hire cars and drivers at times to get ahead of the truck and its caravan, and she shot in whatever light was at hand. Her pictures illustrated a Smithsonian Magazine story that included this still life of "what the well-equipped driver carries," including diplomatic paperwork, tacho disks (like time cards), cigarettes, and coins from nine countries. Kay spread the materials near a large window and photographed them on Kodachrome with an SLR. She used no filter and didn't mind the slight bluish tint.

WHAT IS AVAILABLE LIGHT?

In this book, available light, natural light, existing light, and ambient light are all interchangeable terms. Basically, working with this light can mean shooting in sunny, shady, and rainy daylight, or using artificial light that isn't supplied by the photographer. However, not everyone adheres to my definition; some photographers are more lenient with the term. A friend once told me that W. Eugene Smith, while showing his famous midwife series, said to a group of photographers: "I only use available light." He paused and added, "I define available light as any light I can get my hands on, any light that's available."

No one will fault Eugene Smith's individuality. In this book, however, available light is primarily any type that is already at the place where you're shooting. Flash units or quartz lights are helpful and necessary in many situations, but the world is full of existing-light opportunities to artfully hone your skills and shoot well-exposed pictures. But the definition for available light is certainly not set in stone. If you move a couple of floor lamps to photograph a group picture in your living room, the lights are already on hand and you're simply adjusting them to be more useful. But bringing quartz lights or electronic flash to a situation means you are moving into the applied-light category.

My experience and observations indicate that most serious photographers shoot a lot more pictures in available light, both outdoors and indoors, than by any other means. When photographing children playing, picnics, softball games, parades, or any other kind of outside activity, existing light is usually the best and only way to go. Of course, when you want to casually snap a few shots of people indoors, the urge to use flash is normal. If that is your temptation, fine; but remember, people are less self-conscious and appear more comfortable in natural light than when they're subjected to blinding flashes. And with today's improved fast films, natural-light pictures are much easier to take.

Lewis Portnoy created a personal view of the sun with a 500mm lens and 2X extender on his SLR, exposing Kodachrome 64 at 1/1000 sec. to silhouette the terrain and figure. He asked a friend to run across the horizon for a human touch in a beautifully simplified scene. Lew used a tripod to steady the long lens and to maintain the composition while the runner did his thing during several series of motor-driven frames.

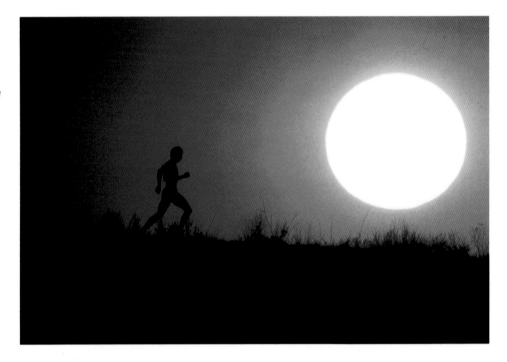

The designers of GUM, the tourist department store in Moscow, provided decent lighting for the period architecture. Lewis Portnoy braced his SLR on a railing and made a 1/30 sec. exposure on Kodachrome 64, shot at f/3.5 with a 28-85mm zoom lens on an SLR. Skylight illumination showed the pattern of people well, and Lew shot a number of pictures from several elevated viewpoints.

AVAILABLE LIGHT PHOTOGRAPHY

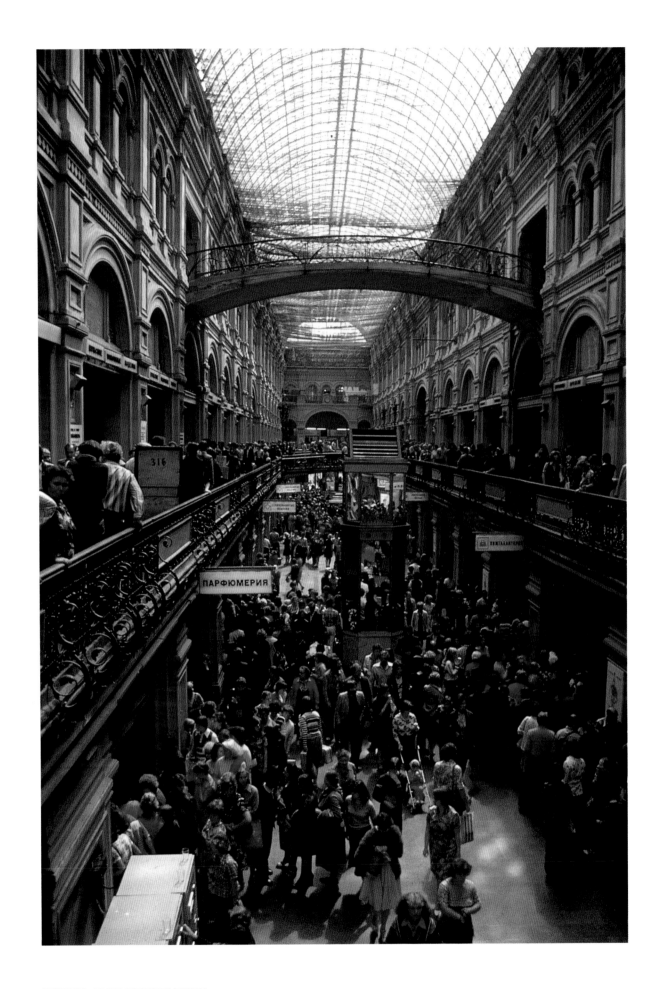

YOU'VE ALREADY STARTED

While traveling, you probably shoot more frequently in available light because you obviously can't light certain situations—such as in a church or museum—with the flash on the camera. But what if you arrive somewhere and the sun is behind the clouds or it is raining? One approach is to either wait for the light to improve or to just quit shooting. Another option is to look for smaller details and patterns, things out of the ordinary, that could otherwise go unnoticed. My feeling, though, is that shooting in lousy light is usually futile.

You may already be familiar with some of the ideas and techniques discussed in this book, and I expect you to rely on your own experience and views when considering my words and pictures. Hopefully, you'll learn new ways to see and photograph all sorts of subjects, and in the process start taking photographic risks by combining the familiar with the untried. Trying something new is the best way to improve what you already know.

Visiting new places stimulates your photographic vision at almost any time of the day. At the famous Mission of St. Francis at Rancho de Taos, New Mexico, it was just after noon in August when I placed an SLR on a tripod with a 28mm lens and polarizer filter. A high sun at noon is not recommended for most subjects, but it worked here on one of the Southwest's most photographed churches. From a lower-than-eyelevel view I framed the mission carefully with the crosses as a repeating theme. The film was Kodachrome 64.

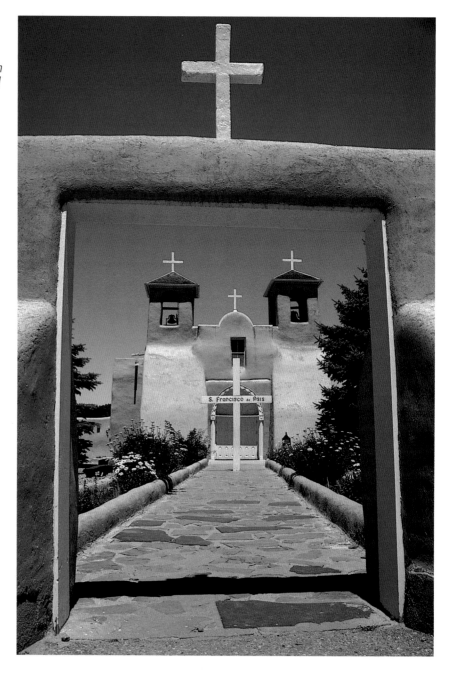

AVAILABLE LIGHT PHOTOGRAPHY

TODAY PHOTOGRAPHY IS EASIER

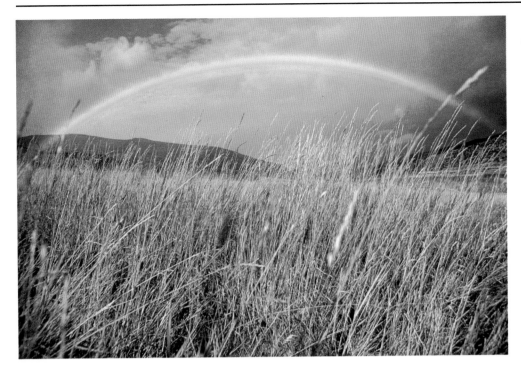

What does it take to catch a rainbow? To start, be there at the right time with the right lens on your camera such as a zoom lens for getting a tight composition. Try to include an interesting foreground, perhaps a silhouette or a detailed texture like this. Lewis Portnoy was driving along a Kansas road after a rainstorm when he saw this display and caught it with an SLR and Kodachrome 64 film. It would also have been feasible to shoot this with a dual lens or zoom lens point-and-shoot camera loaded with an ISO 100-200 print film.

As I said in the introduction, for the first 75 years of photography, existing light from the sun, candles, fires, incandescent lamps, and the occasional powder flash were the only sources of illumination. Incredibly slow films with ISO ratings of 5 and 10 were typical, and the shutters available had only 1/50 sec. and 1/100 sec. capabilities. Life is a lot easier in the 1990s for photographers. Computerized, automatic cameras are readily available and range in price from under $100 to around $2,500. Automatic exposure, which professional photographers have disdained for years, is taken for granted today. Built-in automatic film-winding is becoming more common, and autofocus, considered impractical a few years ago, is now built into dozens of 35mm cameras.

So, today photography in nearly all kinds of light is possible. You may pay for this convenience by putting up with an image that has more grain or some subject motion, but photography without flash is usually worth the risk because using available light may add to the mood and authenticity of the scene. Since the mid 1970s, film technology has taken off, and today there is an exciting variety of print and slide films with speeds ranging from ISO 25 to ISO 3200. Were he still living, Eugene Smith would be thanking Kodak, Fuji, Konica, and Agfa for films like Kodak T-Max 3200, Konica negative color 3200, Ektapress Gold 1600, Fujicolor 1600, Fuji Neopan 1600, or Kodak Ektar 1000. Pictures made from some of these films are among the illustrations in this book.

In the world of equipment, today's cameras can do almost everything except actually compose pictures, and lens technology has kept apace. A 100-300mm zoom lens in the 1960s weighed 3 to 4 pounds and may have been as slow as F6.3. Computer-designed zoom lenses now weigh less than 1 pound and are as quick as F2.8, F3.5, or F4.5. Now it is possible to handhold an SLR with a zoom lens in lighting situations where a tripod would have been mandatory a few years back. All of this means that with today's increased availability of advanced equipment and film, photographs at low-light levels are becoming easier to take and more exciting. While flash is still the expedient light in many situations, it does tend to become boring.

PICTORIAL LIGHT

While you may take pictures in any kind of light, some types are almost guaranteed to make better pictures than others. Sidelighting, for instance, can show the form and texture of an image as well as add drama to portraits, buildings, and landscapes. Front lighting usually flattens such natural forms as mountains, but it can be soft and delightful for portraits. The kinds of light that show a subject best, that dramatize it, and give it that extra emotional appeal, are called pictorial lighting. The best lighting situations are usually the most pictorial and the most visually exciting.

Fortunately, a wonderful variety of pictorial lighting can be applied to natural and manmade objects. You may feel that for a certain subject only one type of light suits the image; but then you can see it at a different time of day and be completely surprised by the different narrative and visual effect the light gives it. This happened to me when I first saw these images of the Taj Mahal in Agra, India. This white-marble mausoleum, built by a shah for his favorite wife in the 17th century, has become a world-renowned photographic subject. On this and the next three pages are five pictures of the Taj taken at various times of the day, somewhat of a rough equivalent of Claude Monet's series of paintings of the Rouen Cathedral.

As in Monet's paintings, changing light on the Taj Mahal creates the mood evoked in photographs of this majestic memorial. Variations throughout the day—relative to sun, moon, and the atmosphere—help us to better appreciate the pictorial phenomenon of light. Tom Atwood photographed throughout a full day at the Taj Mahal, producing some drastically different impressions. He used Kodachrome 200 and Fuji 100 films with a 70-200mm zoom lens on a 35mm SLR and experimented with several views. His moonlight picture was taken on a tripod with three- to four-minute exposures. It is enlightening to see how patience, imagination, and good light can reveal the moods that many tourists may miss.

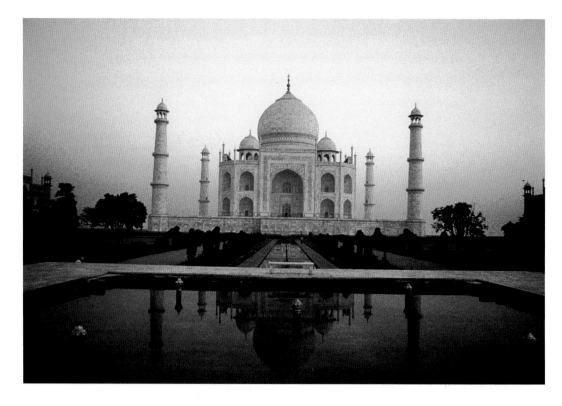

Tom Atwood began photographing the Taj Mahal one day at pre-dawn using a 70-210mm zoom lens. The early light was cool on Fuji 100 slide film. Notice how the mood of the mausoleum changes from one lighting situation to the next. The same place has many visual personalities.

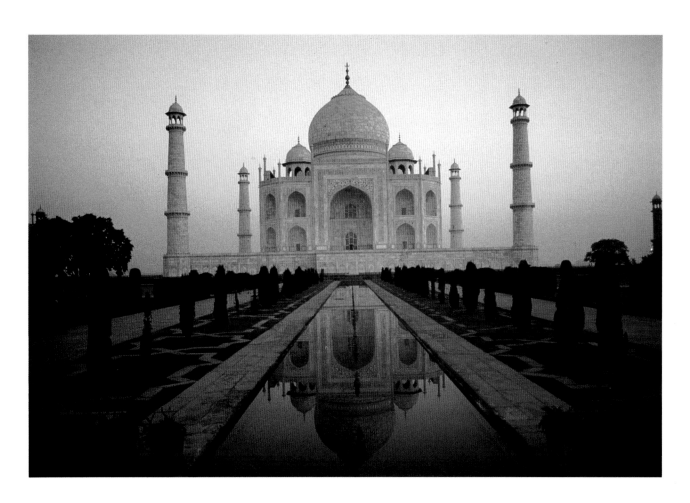

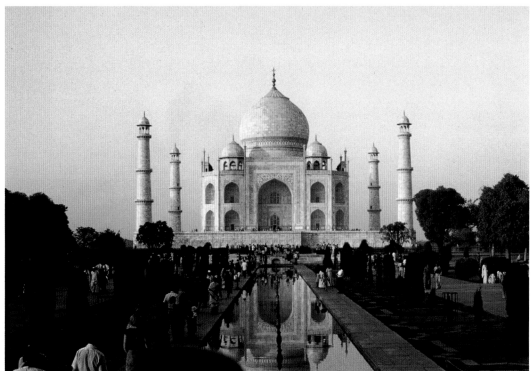

Still pre-dawn about 10 minutes later, the sun's rosy reflection began to tint the Taj Mahal. The light was warmer as Tom moved to another position and switched to Kodachrome 200.

Just before sunset, the light was low, the Taj Mahal was tinted warmly, and visitors were everywhere. The dark foreground provides something of a frame for this jewel of a building.

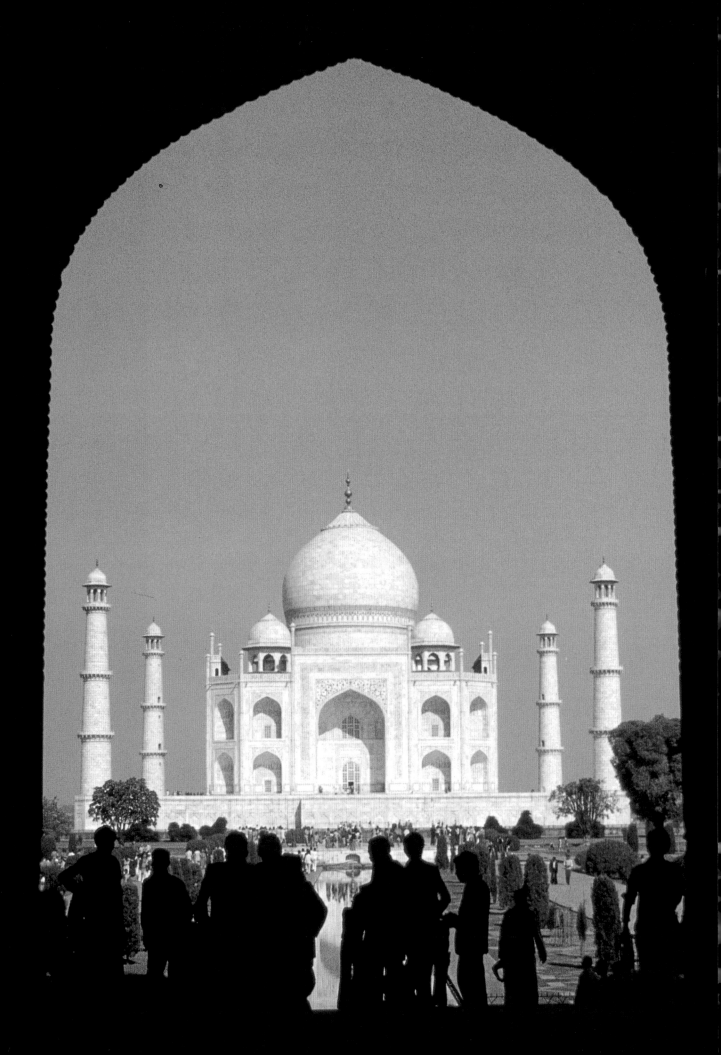

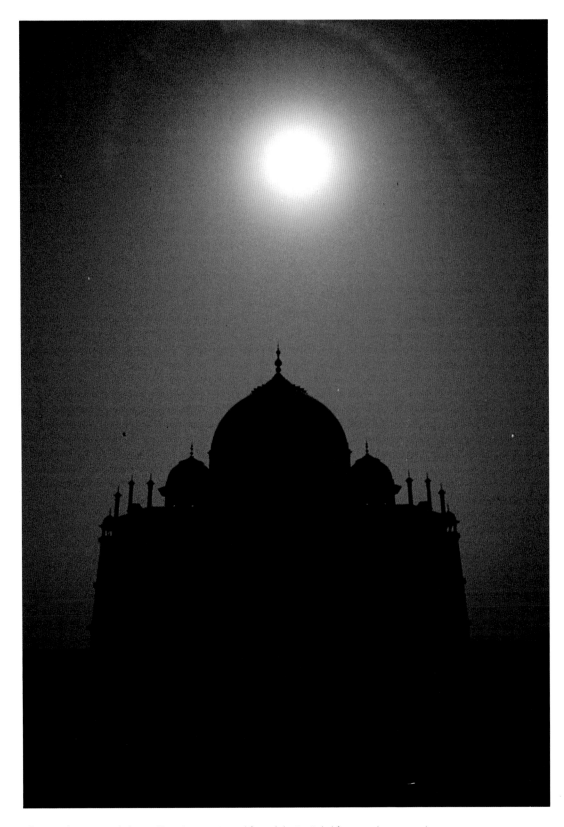

The grounds were crowded at midday when Tom Atwood framed the Taj Mahal from an adjacent temple.
Shot on Fujichrome 100, the silhouetted figures added human interest to the series of images.

When the moon was high and backlit the Taj Mahal, Tom Atwood took his last pictures on Fujichrome
100, using a 1-minute exposure to top the silhouetted monument with moonglow.

EXPERIMENTATION AND CONTROL

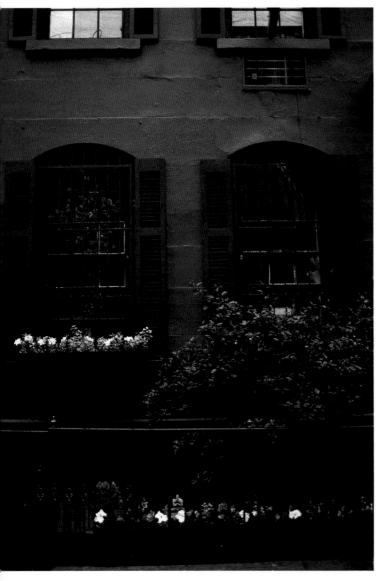

Shadows on a New York townhouse created a low-key situation with accents in the windows, foliage, and flowers. For exposure control the lens was stopped down one stop beyond the meter reading to prevent overexposure since the meter would have averaged the dark subject to make it lighter. For Kodachrome 64 at 1/125 sec. the meter said f/4, and I exposed at f/5.6 using the exposure compensation dial on the camera. I like the moody scene because it is realistic.

Millions of people make snapshots of just about everything and use flash more often than not. Thousands of professional photographers work in studios, simple or luxurious, and 99 percent of the time they shoot with electronic flash or quartz lights. But the rest of the time, most photographs are taken only with existing light. As long as there is enough light to handhold the camera, or a tripod is available, there is almost no limit to what can be photographed. Throughout this book I cover subjects and techniques that might seem familiar because you've already used them and not realized it. Some, on the other hand, may be new. For instance, how often have you used ISO 1600 or ISO 3200 films? Have you taken pictures while zooming a lens during a slow exposure? Do you like making long, timed exposures at night when the unexpected might occur?

Your answers will vary, which is fine. What I want is to encourage you to experiment anywhere you try a new approach, a new lens, a different film, or a strange technique. Pictorial opportunities can be around the world or just around the block. Look for places where faster films would be better than the slower, finer-grain films. Try do decide if some natural lighting in the shade or from a window would give a more dramatic quality to a portrait.

Another key to more satisfying pictures in existing light is the control you have, first through what you see and select to shoot, and then by specific adjustments to the camera. Creativity in your work depends not only on your ability to see the effect the light has on the image, but also to control it with the equipment you use. If you're looking for a precise composition in low-light levels, use a tripod when possible. Adjust the aperture for the depth of field that will fit your interpretation of the subject. Change the shutter speed to achieve either a sharp, frozen image, or a blurred, softer image. Variations in the exposure can also enhance the overall mood of the subject in the light available. A combination of these controls along with your own visual, artistic controls will give you greater satisfaction from your efforts and your images.

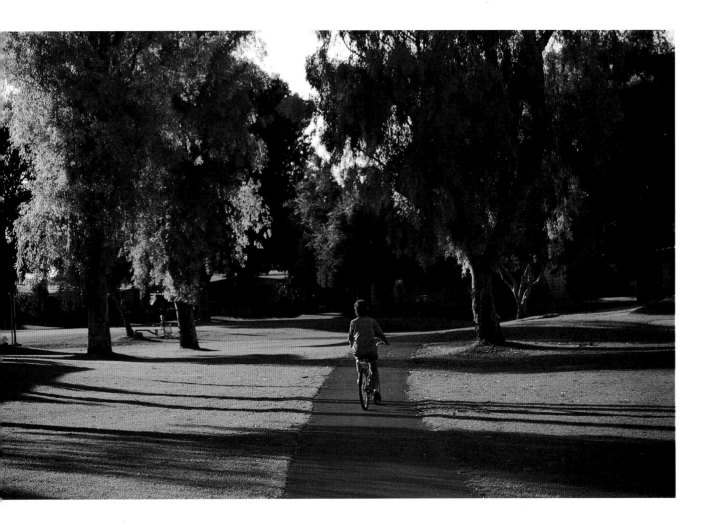

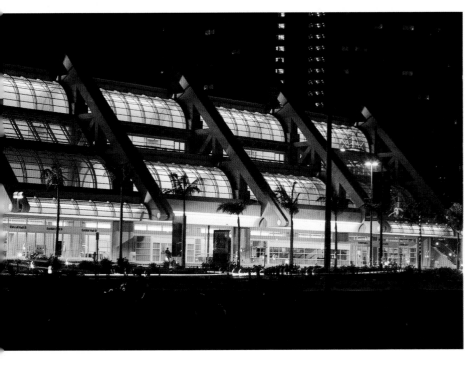

One of the advantages of available light photography is being able to choose the time and place to shoot when the light is just right. Just before sunset I asked a biker to ride through the long shadows in the top photograph. I liked the pastoral look. I was riding behind her with a point-and-shoot camera that has 38mm and 80mm lens settings, and I used the latter with Kodachrome 64.

Time-exposure photography after dark is a wonderful way to use available light. You're never exactly certain what the film will show because it doesn't "see" the scene just the way your eyes see it. A 10-second time exposure at f/6.3 of the San Diego Convention Center would have been entirely fluorescent-tinted, but I swung the camera on the tripod and added some warm spots from nearby lighting fixtures. I exposed a black background behind the other lights for six seconds.

CAMERAS, LENSES, AND FILM

While wandering through an automobile junkyard in Indiana, I discovered this aging truck panel that time and rust had turned into an abstract design. The sidelighting was just right to show the texture. I consider myself an aficionado of junkyards and castoff materials because they make surreal or incongruous compositions. This was made on Kodachrome 64 with a 35-70mm zoom lens.

EQUIPMENT TODAY

I grew up in an era when being able to shoot in dim light was an accomplishment. Photojournalists struggled to capture reality in dark places like rural living rooms and on streets at night. In the 1960s, ISO 200 was considered a "fast" black-and-white film and could be pushed to ISO 400 if you didn't mind excessive grain. Color negative films made back then were only ISO 50 to 100. Now, black-and-white and color negative films are rated up to ISO 3200, and both are readily available. Indeed, advances in films, printing paper, processing equipment, and cameras make this the era of existing light photography. The result is more opportunities for realistic pictures, greater pictorial control, and more mobility with less equipment to carry. These advances can only stimulate your imagination.

A few decades ago 1/1000 sec. was the fastest camera shutter speed available, and mechanically operated shutters were not as consistent as today's reliable electronic controls. Today, shutter speeds of 1/2000 sec. and 1/4000 sec. are becoming more common. In fact, 1/8000 sec. is the top speed on the Nikon F4 SLR. Few photographers may need such high speeds or complex circuitry, but they are available if necessary. Actually, I consider slow speeds more useful than these faster speeds. While 1/1000 sec. is usually adequate for most situations, slow shutter speeds and automatic time exposures can lead to experiments on film with only a small amount of light available. With most modern cameras you no longer have to count seconds for exposure. I still count or use my watch because the slowest shutter speed available with my cameras is 2 seconds. Fortunately though, many SLR cameras, regardless of price, offer automatic time exposures from 20 seconds to 30 minutes, depending on the make and model.

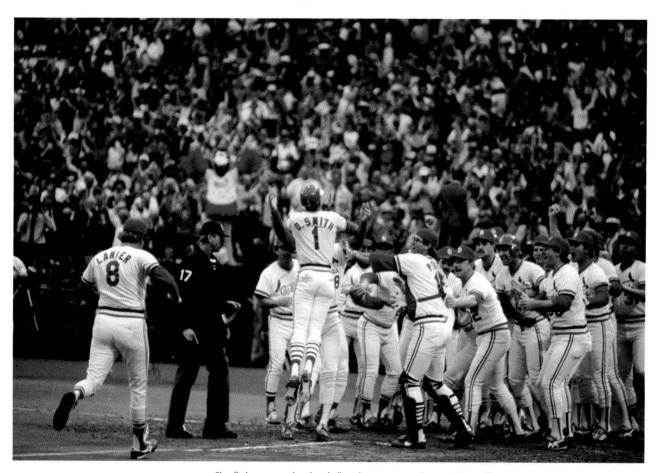

Floodlights at a modern baseball stadium create an almost daylight effect, a circumstance very familiar to veteran Lewis Portnoy who has photographed organized sports for years. Ozzie Smith (#1) had just hit a home run to win the National League pennant for the Cardinals, and Portnoy shot the team's jubilation at 1/500 sec. at f/2.8 on Fuji 1600 print film rated at ISO 800. He used a 300mm lens on his SLR, mounted on a tripod in a third-base box where he anticipated the crowd of players would be at game's end. In daylight he usually shoots at 1/500 sec., a speed fast enough to stop peak action and give him enough depth of field.

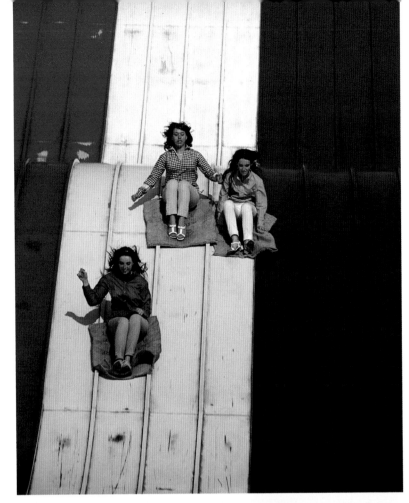

The most practical way to shoot close enough to a subject like this giant slide is to use a telephoto lens on a SLR. I shot with a 300mm lens on ISO 100 Ektachrome with the SLR on a tripod. (If you own a 70-150mm zoom lens, you can convert it into a 300mm telephoto using a 2X extender. You lose a stop or more of light with the extender, but in bright sun you can shoot at 1/250 sec. with ISO 200 film.) Using a motorized winder, I exposed two frames per second.

It was a cloudy day with chilly, blue light, and the view from inside a New York City cab was tinted by the windshield in this picture taken on Kodachrome 64 with an SLR and a 35-70mm lens. Had the shot been made on negative color film, the print might have been warmer because modern processing machines make automatic corrections. I prefer the cool look because it creates a moody impression.

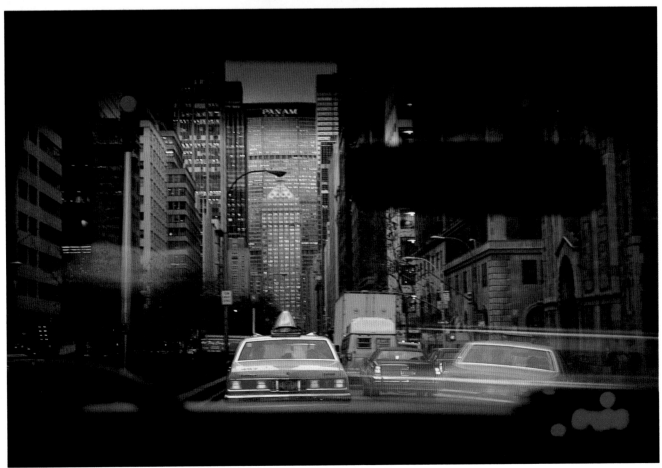

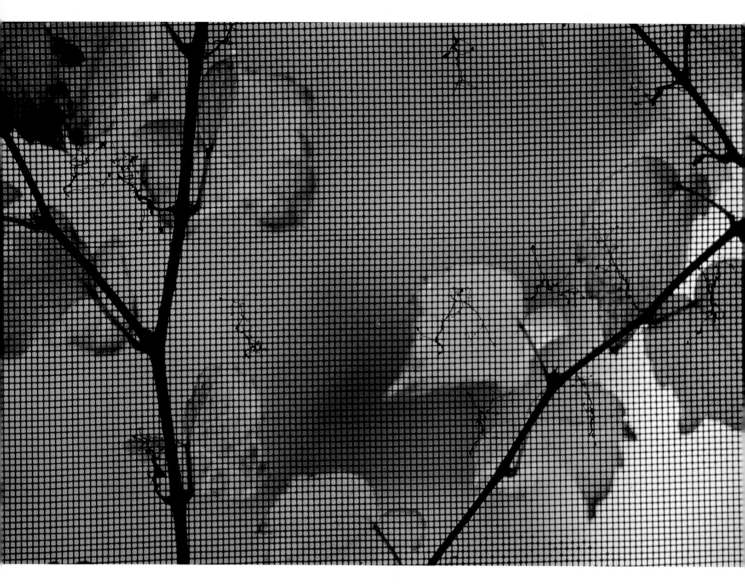

Jay Maisel interpreted the beauty of leaves and sky through a window screen with a macro lens on his SLR using Kodachrome 64 film. Many SLR lenses allow you to get close to a subject, including most zooms. A macro lens is made specifically for close focusing, and a zoom lens can't focus as closely, though at such focal lengths as 80mm or 105mm, large close images are feasible. Jay's photographs are noted for their strong simplicity.

The Grand Canyon of the Colorado River is vast and impressive, especially in early morning when tourists are plentiful as foreground subjects. Here several focal lengths can be valuable to photograph a wide panorama as well as selected areas. A single-lens reflex is ideal, and a couple of zoom lenses are lighter to carry than four or five prime lenses. I used my favorite 28-80mm zoom at 80mm here and a tripod because it makes me think more carefully about composition.

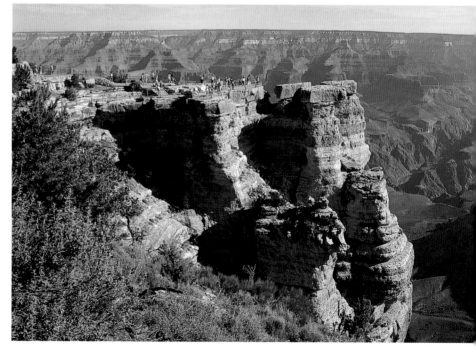

AVAILABLE LIGHT PHOTOGRAPHY

For low-light photography it is extremely helpful to have as fast a lens as possible. Lenses rated at F1.2 or F1.5 are designated "fast" because these maximum apertures are larger than on most other lenses. Thus, when the level of the available light is low and you choose not to use flash, the larger aperture lets in enough light to allow you to shoot at higher shutter speeds. Today, fast lenses are fairly common in the single focal-length category, but many of us are more likely to rely on zoom lenses rated between F2.8 and F4.5. These are primarily considered "outdoor lenses," but with today's remarkably fast films, zooms can be very effective in low light. So instead of carrying a 12-ounce lens with a single focal length, you can now carry a 7-ounce zoom lens with a range of 35-70mm.

While high-tech equipment makes shooting in existing light less of a strain, it is still the photographer who creates strong compositions and impressive images. Precise, consistent technique comes only with experience, but your choice of cameras, lenses, and film has a strong influence on your pictorial skills. For example, I like to travel light when I fly somewhere for a business meeting or short assignment. On a recent four-day trip to the Midwest where I knew that much of my time would be spent indoors in conference-type settings, I took two matched single-lens reflex camera bodies, one with slide film, the other with print film. I chose an F3.5-F4.5 28-80mm zoom lens that weighs 14 ounces, and a compact F2.8 21mm wide-angle lens. I used the zoom lens for everything from a few outdoor opportunities to some museum photos, as well as for a few group shots used for publication. The 21mm wide angle was great at a party in a crowded room and for the increased depth of field. I used Kodachrome 64 slide film and Kodak Ektar 1000 and Gold 1600 print films; both are excellent for poor light indoors.

A good SLR camera is likely to produce satisfying pictures in a variety of lighting situations more often and more easily than any other camera format. While the larger and heavier medium-format and view cameras make very sharp pictures for enlargement, they are not very portable, and most of the time you need a tripod. You may also choose a 35mm rangefinder camera, but the modern ones have a somewhat limited number of lenses available with no capability for zooming. Rangefinder cameras are much quieter than SLRs (they have no mirror to flip up and down) but lack versatility. An automatic point-and-shoot (P&S) camera is a light-weight pleasure, and some models have built-in zooms and versatile shutters; but none really match a good SLR with its interchangeable lenses and wide range of accessories. Many SLRs now offer autofocus lenses and other electronic conveniences found in point-and-shoot cameras. And zoom lenses preclude having to carry a huge collection of lenses for most average picture-taking needs. I believe that the more comfortable you are with your camera and the more focal-length choices you have, the more motivated you'll be to shoot everywhere, especially in existing light. Mobility and automation can easily lead you into photographic adventures.

BUYING A CAMERA

Modern equipment is seductive, and I suggest you keep in mind that while brand names are important, there are plenty of camera and equipment makers from which to choose. Status symbol brands and models may help build your self-esteem, but the prints and slides you get from them are what really count. If you're planning to buy a camera, talk to your friends about their favorites and study the ads and articles in a few issues of the various photography magazines on the market. Visit a well-equipped camera shop, and discuss the possibilities with a salesman. Study camera brochures to determine the specifications on each system. Try not to be tempted by those with more exposure modes, readouts, and electronic components than you care to use. And as you make decisions, ask yourself a number of questions:

- What kind of pictures do you like to shoot and what would you like to try shooting? Can you shoot a wide number of subjects—landscapes, portraits, sports, still lifes, and nudes—with the brand and model you prefer?

- Do you want a camera that makes exposure decisions itself, one that gives you the option to choose shutter speeds and lens openings, or one that does both?

- Will you be shooting mostly outdoors in good light? If not, do you prefer built-in flash, or will a separate flash unit be more practical?

- Do you want slow shutter speeds that enable you to capture the mood of a scene without flash in low-level existing light?

- How much weight and bulk will you be comfortable carrying? Do you want to carry more than one shoulder bag for the equipment you'll take on long or short trips?

- Do you want to be able to use an assortment of lenses from superwide-angle to telephoto? Do you know which focal lengths you want first? Are zoom lenses the best answer?

As you try to answer these questions, keep in mind that your goal is pictorial control. Having the right equipment means that you are more capable of capturing or creating the images you can see and imagine. Think about it carefully so you won't find yourself needing more features or wishing that the ones you do have weren't so complicated. The more complex your camera, the more beneficial it is to review the instructions. Learn things like how to change film in mid-roll on a camera with automatic rewind or how to make exposure compensation settings. It is also a good idea to carry a manual in your shoulder bag; it is easy to forget how to operate some of those controls.

A group of flamingos is a pictorial attraction no matter what kind of camera you use. This was taken with an SLR camera at Sea World in San Diego, but it could have been taken with a P&S or a handheld medium-format camera. However, creative control over depth of field and shutter speed is an advantage that most P&S cameras don't offer. The type of camera you use is usually decided by personal taste, comfort, and what you want to do with the pictures.

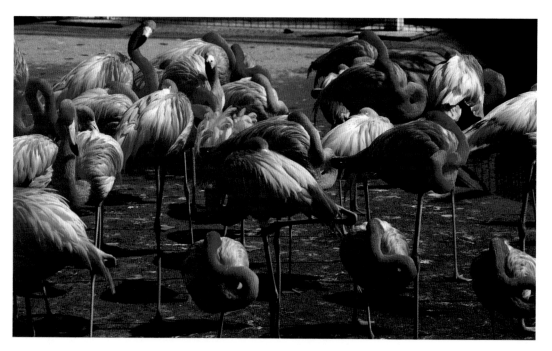

35MM SLR CAMERAS

Perhaps the format with the longest list of system accessories and the widest range of capabilities is the 35mm SLR. First of all, you can interchange dozens of lenses, ranging from a 6mm fisheye to a 1200mm telephoto. You can also preview depth of field in many models by pressing a button on the side of the lens. The electronic automation available for SLRs is always increasing. A vast majority of cameras include automatic exposure and autowinding. Many models also offer automatic focus, rewinding, multiple exposure modes, and options for special creative effects, all in surprisingly compact bodies. The ability to shoot a fast-moving subject or a subject in poor light with an autofocus camera is a distinct advantage that many professionals appreciate. Some makers build in several metering modes—such as averaging, spot, and program—for more creative control, though the averaging mode is the most widely used. Choice of exposure modes such as shutter-preferred, aperture-preferred, or program are also available in some brands. Other features offered are multiple-frames-per-second sequence shooting, automatic flash fill, and data panels that show camera functions. Closeup pictures are made easy by using macro lenses, or zoom lenses that include a macro mode, and such accessories as bellows, extension tubes, and reversing rings.

Flash fill is used to brighten shadows in a scene. If used properly, the flash will augment existing light but won't overpower it. In many modern SLRs and point-and-shoot cameras, exposure for the built-in flash units is computed automatically by the camera. The larger, "dedicated," add-on units are matched to the through-the-lens (TTL) exposure systems. Soft flash fill for portraits is often a blessing in backlighting situations because it allows you to maintain a sense of the existing light for the background and surroundings. Flash units built into cameras are usually small but adequate, and they become more powerful as faster films are used.

In the early 1970s automatic exposure came to SLR cameras. In the 1980s built-in autowinding was added and then autofocus, a feature many "experts" had said would be impossible. The technology is fascinating and mysterious to me, but the main point is that it works. Tiny motors focus the lightweight lenses from multiple readings made by infrared sensors. Some models now have "predictive" autofocus that adjusts itself for fast-moving subjects. In low light levels, autofocus actually "sees" better than your eyes because of the infrared sensor process. Most autofocus SLRs allow you to focus manually, too. When you're comparing cameras, check out several autofocus types. An autofocus model may cost slightly more than manual focus, but in my estimation the cost is worth it. You're buying technical peace of mind so you can concentrate on action, expression, and composition instead. The camera makes adjustments, but you call the shots.

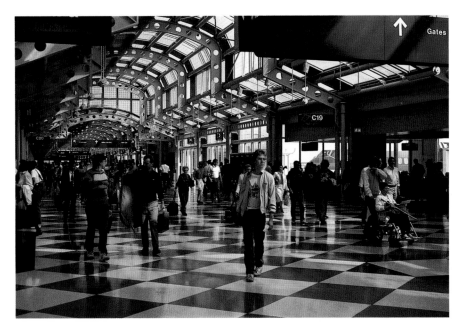

United Airlines terminal at Chicago's O'Hare Airport is an excellent place for available light photography with an SLR. You can stay out of the pedestrian traffic pattern and yet vary your viewpoint with a wide-angle lens or a zoom that includes a wide-angle setting. The structure makes a great frame for people on the move, and the light is bright enough for films rated ISO 64. I used a 28-80mm zoom and shot on Kodachrome 64 with the lens set near 28mm.

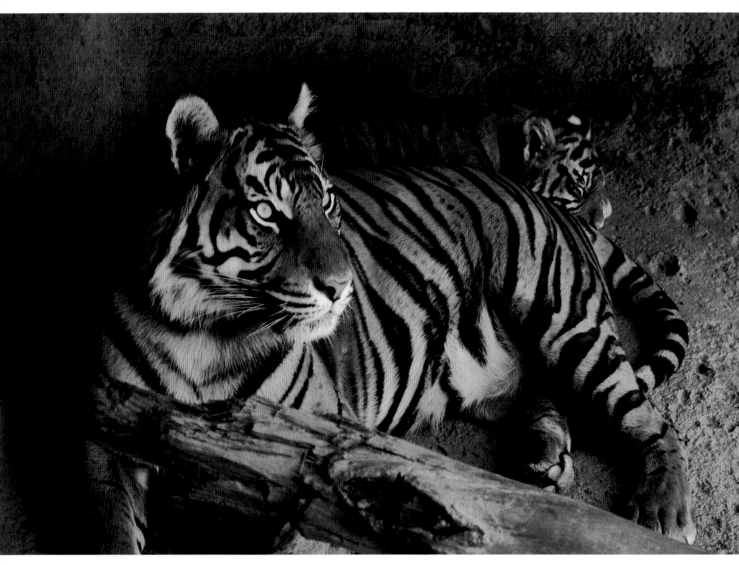

Tigers in the San Diego Zoo rest in a shady nook behind a large window. With Kodachrome 64 the exposure was 1/8 sec. at f/4, which I could handhold only by bracing the camera against the glass. Since most zoom lenses are about f/3.5, an ISO 200 or 400 film is an advantage in dim-light situations. Sometimes I carry two camera bodies and load one with a faster film such as Kodachrome 200 or an ISO 400 or 1000 print film.

LARGER-FORMAT CAMERAS

I said earlier that medium-format cameras and view cameras were mainly professional equipment. A lot of commercial and advertising photography requires cameras with larger finders to compose the image more precisely. And the increased size of the negative or transparency (120mm, 220mm, 4 x 5 inch) allows for sharper blowups and for easier viewing by the client. There are other technical advantages to owning the larger formats, such as perspective control and the Scheimpflug effect, but few of these are needed by amateur photographers. View cameras and other special application equipment are great when there is enough available light and a certain effect is needed, but these are clearly professional tools and often require additional lighting for precise compositions.

Many non-professionals choose larger-format cameras (primarily medium-format, such as 6 x 6cm, 6 x 7cm, and 6 x 9cm) because of the larger image in the viewfinder, the great versatility of the larger format, or simply because the larger transparency looks more impressive on a light table. Such cameras are not suitable for many low-light conditions without a tripod because typical lens apertures for medium-format and view camera lenses range from F3.5 to F8. That's not a handicap in appropriate settings when subjects are still or when electronic flash is handy, but an SLR on a tripod has the same capabilities and handles easier. And the increased size of the camera can work for and against you. The added weight of many medium-format SLRs dampens unwanted vibrations from the mirror, but having to carry almost double the weight can become a burden.

Most medium-format SLR cameras (for example, Hassleblad, Bronica, Rolleiflex, Pentax, and Mamiya) use 120 film, which is about twice the size of 35mm film, and many models include automatic exposure metering and power winding. For those who prefer shooting larger negatives or transparencies, the price of a medium-format system, not to mention the increased weight and size, may be worthwhile. Keep in mind that a typical medium-format camera may weigh 4 to 6 pounds compared to a 35mm SLR that weighs about 1.5 to 3 pounds. It is my belief that the 35mm SLR is appropriate for a majority of serious photographers, both amateur and professional. About 99 percent of the black-and-white and color photographs in this book, and most of what you see in magazine stories and illustrations, are made with 35mm SLR cameras. In advertising, fashion, and still-life photography though, medium and large format are usually the cameras of choice.

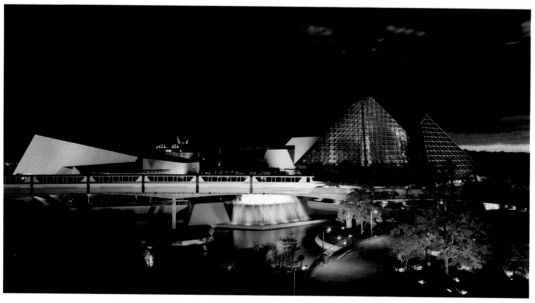

A striking pavilion at Disney World's Epcot Center was photographed at night by an Eastman Kodak photographer with an 8x10 view camera for a display at Grand Central Terminal in New York City. A view camera is often used for architectural pictures because the back and lens tip to assure vertical lines. Color contact prints made from a large transparency or negative are sharper than enlargements from smaller film sizes.

35mm POINT-AND-SHOOT CAMERAS

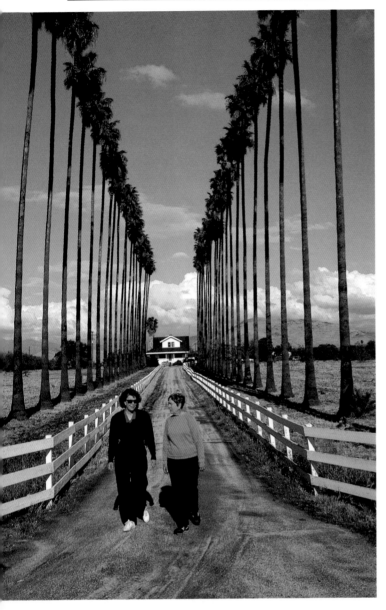

This California scene was taken with a "bridge" camera, so named because it is more sophisticated than the average P&S but doesn't have a removable lens like an SLR. The camera has many automatic features and a built-in 35-105mm zoom. I borrowed the camera from my friend in the pink sweater and found it was pleasant to shoot with and had more features than my P&S. It cost a lot more as well and was bulkier.

Point-and-shoot (P&S) cameras are fairly compact with a full range of automatic features and are generally more than adequate for basic picture-taking needs. The problem is that they are extremely limited when it comes to lens selection, exposure modes, and other accessories. The model I own has a dual focal-length lens: 38mm and 80mm. Better yet are the models with zoom lenses that can be used at any focal length in the available range. Most point-and-shoot cameras have built-in electronic flash plus automatic exposure, autofocus, autowinding, and automatic flash-fill.

Most of the point-and-shoot cameras on the market now are very compact and easy to carry. The lenses are adequately sharp, but certainly not as sharp as the average SLR lens. If you're going to be shooting in low-light situations, choose a model with at least an F2.8 lens and as many slow shutter speeds as possible. And be aware when the combination of low light and slow film makes it necessary to either brace the camera or use a tripod. You can activate the flash on some camera models for backlighting or when you know you're going to get camera movement.

Built-in flash comes in handy in contrasty outdoor locations to illuminate shadows, and it is essential in poor light indoors and almost everywhere at night. The trick is to know when flash is worthwhile and when you'll get better looking pictures in existing light alone. Unless you have a fairly fast lens, such as F2.8 or faster, you'll need flash at specific times. Luckily, many of today's point-and-shoot cameras loaded with ISO 200, 400, or faster films allow you to work without flash and increase the natural look of many situations.

There are also disadvantages to using a point-and-shoot camera. The lens' focal-length range is limited to what is on the camera, and you can't manipulate film speed or make exposure compensations manually. Only on a few models can you change film in mid-roll. Close-focusing distances are limited to a few feet, as compared to inches with an SLR. Flash may fire when you don't want it to and it can be disconcerting to never really know what shutter speed or aperture you're using. A point-and-shoot camera is wonderful for less-than-serious photography because it will usually lack the features needed for real pictorial control. And while most of the models on the market cost less than an SLR, a few of the more advanced cameras that have multiple focal-length lenses can cost as much as or more than many of the good SLR models.

CHOOSING A LENS

The huge selection of lenses for 35mm SLR cameras has helped make the format so popular. A majority of these are manual-focus lenses, but the list of autofocus zooms and single focal-length lenses for SLRs is growing steadily. New lens formulas, materials, and manufacturing processes have resulted in smaller, lighter lenses you can handhold more readily in existing light. For comparison, I have a 14-year-old 80-200mm zoom that weighs 32 oz., and a new 70-210mm zoom weighing 14 oz. Both offer close focusing, but now I can carry more equipment without straining my neck.

Though you can shoot pictures in sunlight, shade, rain, or at night with any lens, you are making a creative decision when you choose a specific focal-length lens to suit a subject or situation. For example, when shooting in a crowd, a wide-angle lens like the 21mm, 24mm, 28mm, or 35mm is the most useful. A wide angle has inherently good depth of field to keep subjects both near and far in focus. When you can't get close enough to something, using a 135mm, 150mm, 200mm, or longer lens is a real asset. Zoom lenses can give you more freedom by allowing you to change focal lengths more rapidly and thus catch those subjects that otherwise might be lost.

The less available light there is, the more you need fast films and large-aperture lenses to handhold your camera. However, because of fast films, lens apertures like F2.8 and even F3.5 are often adequate today. A lot of zoom lenses have F3.5 apertures, indicating that zooms are more

suitable for handheld work where there is enough light to shoot wide open at 1/60 sec. or faster. Fortunately, when light levels are low and you need to shoot without a tripod, a film rated ISO 400, 1000, 1600, or 3200 can boost the possibilities with a zoom lens. With an F1.8 lens at maximum aperture, depth of field is quite limited and you need a faster film to stop down and get more of the image in focus. Film characteristics are covered in more depth later in this chapter.

Choose lenses carefully to give yourself as wide a selection of focal lengths as you can afford and care to carry. Match lenses to the subjects you like to shoot and the kinds of ambient light pictures you like to take or want to try. And use a tripod as often as possible to avoid camera shake and to provide greater depth of field by decreasing shutter speed. While owning a lens in each focal length category is not necessary to shoot successfully, it certainly does help. When working with a particular lens, at least be familiar with the characteristics of its focal-length ranges so you can make useful pictorial decisions. Here are the types of lenses you can choose from:

Superwide-angle: In this category are fisheye (15mm, 16mm, 17mm), plus 21mm and 24mm lenses. These are wonderful for planned perspective distortion, for picturing a whole room from a single viewpoint, for amazing depth of field at fairly wide apertures, and for certain bizarre effects. A superwide-angle lens is somewhat expensive; when you decide to purchase one, first

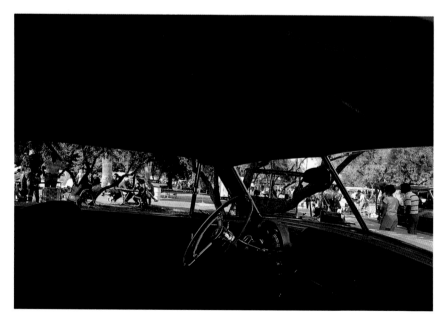

The available light pictures in this book were photographed with a variety of lens focal lengths, each of which was chosen to dramatize the subject and compose it as carefully as possible. At a showing of antique cars in Palm Springs, California, the scene was framed through the interior of an old Hudson to help symbolize the event. Using a 21mm lens at f/16 gave me excellent depth of field on Kodachrome 200. Because of the scene's dark top and bottom, the camera meter would have overexposed the center portion, so I took a reading from above the car and set the indicated exposure manually.

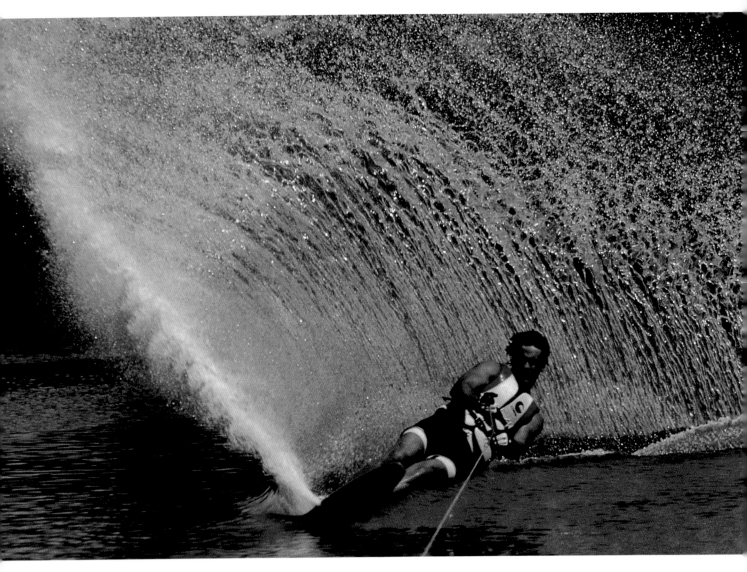

Lewis Portnoy makes the most of telephoto lenses and extended-range zooms in his work. Here he used a motorized SLR and a 100-300mm zoom lens to stop a water skier in Florida on Kodachrome 64 at 1/500 sec. Unlike many professionals, Portnoy accepted zoom lenses as soon as their sharpness was assured by the manufacturer of his SLR. He says, "Zoom lenses make following action much easier, and they have been my trademark since the early 1970s when I first used one to photograph ice hockey games."

try several on your own camera and guesstimate how you would use them.

Wide-angle: In this category are 28mm, 35mm, and 40mm lenses that are great for dozens of situations from group shots and cityscapes to photographing patterns from a fairly close viewpoint. Because of the distortion, neither wide-angles nor superwides are good for portraits, but the increased depth of field available makes the lens worth its price. Note that because a wide-angle lens often includes a lot of sky in scenic shots, the sky may disproportionately influence a meter reading toward underexposing because of the brightness. Compensate by adding 1/2 stop when necessary, or bracket the shot. Shoot some test pictures of landscapes with sky using wide-angles lenses and keep notes.

Normal to semi-telephoto: This range runs from 50mm to about 105mm. A 50mm lens is a general

purpose focal length for portraits, scenics, and closeups. A fast 50mm lens (F1.5, F1.8, or larger) is useful in low-level existing light, and it is compact. Before you buy a 50mm lens, however, consider that some zoom lenses include 50mm and that owning a zoom will definitely extend your photographic prowess. Short-range zooms in the 35-70mm range are about the same size and weight as a 50mm. Focal lengths from 80mm through 105mm are semi-telephotos—excellent for portraits, scenics, sports events, and closeups—but many of these are also covered by zoom lenses such as 35-105mm, 70-150mm, and 70-210mm.

Telephoto: Lenses that are 135mm and longer are considered telephotos. Most of these lenses have superb optics to close the distance between you and the subject; and with the new technology, they have become lighter and smaller. Long focal-length lenses, including the zoom lenses in the telephoto range, are wonderful for scenics, sports events, and shooting all sorts of distant subjects. You can usually handhold an SLR with a telephoto lens when there is enough light, but some of the bigger models (500, 800, 1200mm) almost always require a tripod to prevent camera shake.

Close-focusing: A single focal-length (prime) lens may focus as closely as 18 to 36 inches from a subject. On the other hand, a macro lens is designed to focus at one or two inches from the subject and may make life-size 1:1 images. A 50mm or 55mm macro lens can also be used as a normal lens, though it is likely to be F2.8 or F3.5. Zoom lenses often do a terrific job of close-focusing in a "macro mode." A zoom lens can give you a 1:4 image at its longest focal length, which is adequate for lots of closeup photography. Other closeup equipment—such as diopter lenses, lens extension tubes, and bellows—may be necessary to shoot closer than a close-focusing zoom allows, but using a macro lens would be my first choice. Diopters are easy to add to an existing lens and are relatively inexpensive. Extension tubes are a bit clumsy, but bellows allow a lot of focusing latitude in many closeup situations. Most SLR metering systems automatically compensate for any exposure changes with coupled diopters or macro lenses; however you might have to compensate manually for those extension tubes or bellows that have no coupling capabilities.

Zoom Lenses: You've heard a lot of praise for zoom lenses in this book because I'm convinced that zoom lenses can efficiently do the work of many prime lenses. Modern zooms are generally as sharp as many high-quality prime lenses, and there is no real way to tell which was used in the pictures you see in magazines, books, or exhibitions. More than three quarters of the pictures in this book were shot with zoom lenses. My current favorite lens is a 28-80mm that can be used for portraits, interiors, some scenics, and many other subjects. I'm also fond of a 70-150mm that is slightly lighter than the 28-80mm, and I enjoy the 70-210mm mentioned earlier. Other useful zoom ranges are the 24-50mm and 35-105mm.

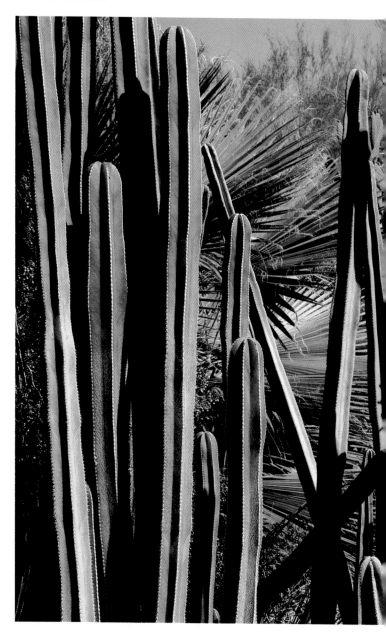

In the colorful Moorten cactus gardens in Palm Springs, I spent a mid-morning hour with my SLR on a tripod photographing cactus for my stock file. This shot of a fencepost cactus was composed with a 35-70mm zoom lens, contrasting its strong textures against the slim palm leaves behind. You could shoot here easily without a tripod, but using one assures more professional results.

FILTERS

Photographic filters have two primary functions: to correct the color temperature of the light to suit the film you're using, or to specifically alter or enhance an image. I often use a 1A skylight filter with color film to warm the colors in shadows and on cloudy days. Other similar filters—the 81C, 81EF, and the 85C—have much the same effect. A Tiffen FL-D filter is used primarily to reduce the greenish tints when shooting with daylight slide film in fluorescent lights.

Another thing to keep in mind is color temperature and how it relates to the type of film you are using. All light can be measured on a color temperature scale in degrees Kelvin. For example, a cold cloudy sky is about 6000K, noon sunlight is about 5600K, afternoon sunlight is 4500K, a 100 watt tungsten bulb is 2900K, and a candle flame is about 1900K. Color films are made to match daylight sun as well as artificial light in the 3200-3400K range. Where the cooler light of shade on a cloudy day gives pictures a bluish tint, using a 1A skylight filter can help you to balance out the color.

Other types of filters are designed to enhance

photographs. A polarizing filter is invaluable for darkening skies and reducing reflections with all black-and-white and color films. Neutral density (ND) filters, 2X and 4X, "tame" the speed of fast films without affecting color. For instance, if you're shooting indoors with an ISO 1600 film, use an ND filter when you move outdoors to slow the shutter speed and increase the aperture. Other filters designed for special effects include colored filters for intentional distortion, split filters for selective focusing in the image, diffusion filters, and soft-focus and multiple-image filters. A good rule of thumb for color is to start with the polarizing, skylight, Tiffen FL-D, and ND filters.

For black-and-white photography, the yellow K2 or K3 filters, the green X1, orange G, and the red 25A filters are all used to darken blue sky and lighten clouds for better contrast and effect. The polarizer, ND, diffusion, and other special-effect filters can all be used with black and white. Fortunately, automatic metering systems make the exposure compensations that are needed once the filter is mounted.

While photographing Vanderbilt University, Will and Deni McIntyre planned a sunset scene on the Alumni lawn. Will says, "We used a 24mm lens on an SLR and Kodachrome 64 film with a Cokin "P" series sunset filter plus an 81C amber filter for extra warmth. Deni is great at making filtration look natural. She may stack several filters and combine tints that turn out looking very natural.

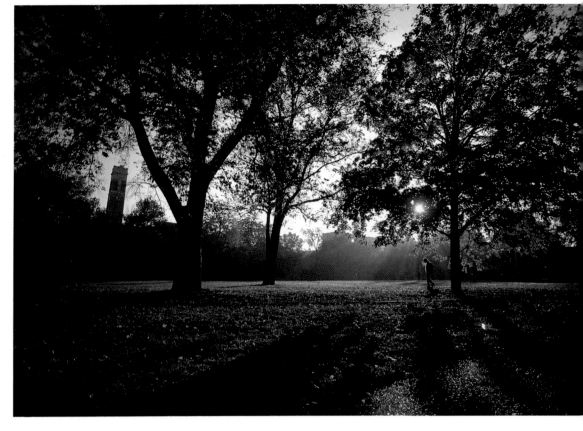

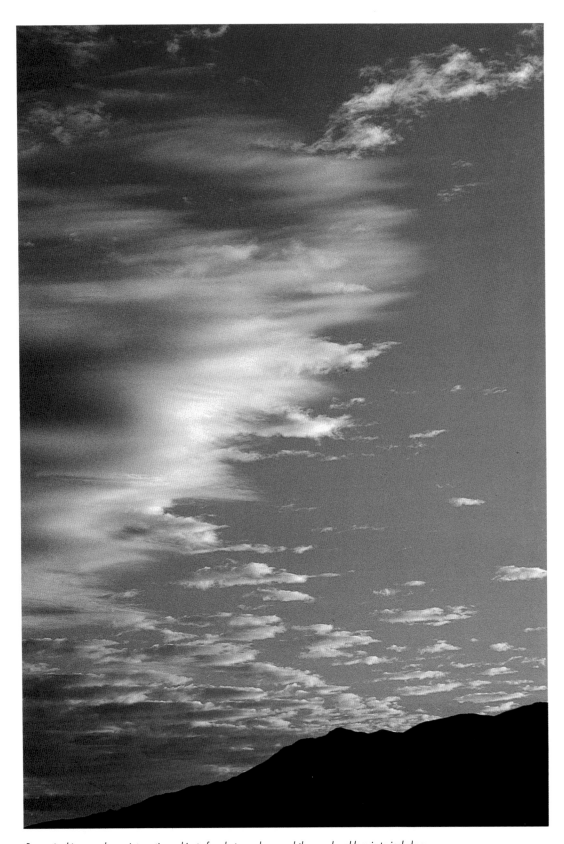

Dramatic skies are always interesting subjects for photographers, and the usual problem is to include a foreground that also has some visual interest. Sometimes, but not always, a polarizing filter helps deepen blue sky as it did here. To find out how effective a polarizer will be, rotate it in front of your eye. If the difference is slight and you are handholding the camera, don't use the filter because you'll have to use a slower shutter speed or larger lens opening or a little of each, which can cause camera movement and shallow depth of field.

COLOR PRINT AND SLIDE FILM

Color photographers are divided into two camps: print film versus slide film. Many amateur photographers prefer color negative film because it is convenient to show prints, save them in albums, and have them enlarged for display. Since most color-negative-film development and printing is entirely automated, the cost of color prints is nominal and varies with the photography lab you use. Processing for color slide film is slightly more expensive than having color prints made; but black-and-white film processing and printing is more expensive than color because it is less automated and fewer labs do it. The advantages of black-and-white are that developing and printing the film yourself is often cheaper and the work can be more creative.

Shooting color negative film is easier than shooting slides mainly because color negatives can be exposed in either daylight or artificial light without any filter correction. During automated processing or home-darkroom printing, color can be corrected or altered with the proper filters. Color negative film can record high contrast scenes with more highlight and shadow detail than slide film, though the difference is small. Negatives can be a stop overexposed and half a stop underexposed, but the prints can be manipulated to the correct levels. For color slides though, exposure must be within a quarter stop for brilliant colors; and while underexposure is okay, overexposure should be avoided. Also, the fastest color print films are faster than any slide films and almost equal to the fastest black-and-white films.

In existing light, outdoors or indoors, you can use print film more casually because it is so adaptable to different light sources. As for which print film is "best," that depends on your taste and pictorial needs. Photographic magazines carry

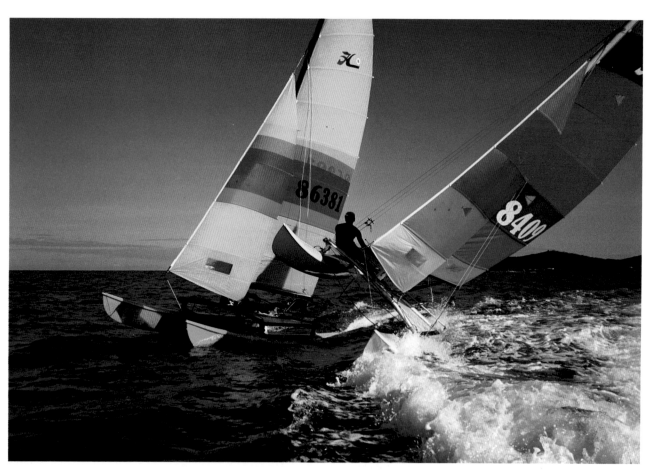

This dynamic photograph of catamarans in full sail was once on view as a Kodarama, a giant 30 x 50-foot display transparency located on a Times Square hotel in New York City. The 45-degree light beautifully illuminates the subject and silhouettes one sailor in the shade. Kodak photographer Neil Montanus used a 35mm camera and Kodacolor VR-G 100 film (a professional negative film). The image was enlarged several times on its way to being 50 feet long.

occasional detailed color film tests in which one subject is exposed on many different films and the color characteristics of each type of film are compared. The results are somewhat similar, but you should decide for yourself which film types and brands will suit the types of photographs you'll be taking. A rule of thumb is that the faster the film (slide or negative), the grainier it is and the less color saturation it offers. If you elect to avoid the synthetic look of flash in low-light conditions, you should be ready to live with grain and the slightly less bright color of prints made from some fast films. The fastest films—such as ISO 1000, 1600, or 3200—are not suggested for bright sun. An exception is Kodak Ektar ISO 1000, which maintains color saturation extremely well. For more flexibility when you shoot, use two camera bodies with a different speed or type of film in each.

There are too many color print films to evaluate all of them here, but I'll list some so you'll at least be aware of them. Fujicolor comes in a full range of speeds including Fujicolor Super HR 1600 and the premium priced Reala 100 with an extra color emulsion and super-fine grain. Reala also allows you to shoot by fluorescent light without getting those sickly green skin tones. Kodak makes a complete selection of Gold films plus the very slow Ektar 25; it should inspire you to use a tripod. Ektar 25, 125, and 1000 are better balanced than Kodak Gold films for fluorescent light. Agfacolor is available as XRC 100 and 200, and XRS 1000, all recently improved. Konica offers its own color negative films including the very fast SR-V 3200 plus slower speeds equivalent to those offered by Kodak, Fuji, and Agfa. Kodak and Fuji also make some color negative films marked "professional" that, according to both companies, offer slightly better picture quality. More newspaper photographers are using fast color negative films in available light because both black-and-white and color enlargements can be made and processed quickly. I suggest you experiment with the films of your choice to discover if the extra cost is worthwhile to you.

It seems that point-and-shoot cameras are designed mainly for color negative films for at least two reasons: You can't make exposure compensations that benefit some slide films, and you can't change film in mid-roll. I usually keep ISO 200 Kodacolor in my point-and-shoot camera, although I like Fujicolor and have seen good results from Agfa, Konica, and Scotch films. The differences are often subtle. Kodak film is available

everywhere and I'm familiar with its characteristics, so it is a welcome habit.

Meanwhile, in the color slide camp are most professionals and many advanced amateurs who prefer transparency film because it is favored by publications for the fidelity of the colors. The color in prints made from color negatives can be altered during processing by filter manipulations, unlike the color in a correctly exposed and processed slide. But slides last longer without fading than prints made from negatives. And Cibachrome prints made from slides are more stable than other types of color materials commonly used. Most slide films are balanced for daylight, and you'll need corrective filters for proper color shots in mixed-light sources or in light that doesn't match the film type. There is also tungsten-balanced slide film that produces intriguingly bluish transparencies if you use it outdoors. Prints can be made from slides, and slides can be made from color negatives, though neither are quite as good as the originals.

My favorite film is Kodachrome 64, although I like shooting Kodachrome 200 in good light and some dim light situations. I've also used slide films from Fuji and like the results. However, Kodachrome has the greatest longevity and serves many purposes. Kodachrome 200 is similar to 64 in color characteristics and the grain is minimal. The fastest slide film I've used is Ektachrome 800/1600; it can be shot at ISO 400, 800, or 1600 when push-processed. I generally rate the film at ISO 800 where the grain is noticeable but not quite objectionable.

There are differences between the films aimed at professionals and those made to suit amateur needs. Color films have complex emulsions made up of various chemical compounds that tend to change slowly with time. As film ages toward its "expiration" date, its color balance, or response, changes slightly. Kodak and other film manufacturers incorporate small compensations into most amateur films for color changes that will occur with room-temperature storage and any delays before processing. But professional photographers are more demanding. They want a film that has reached its optimum color balance when they expose it, so professional films are actually aged to that ideal point. Then they are sent to the dealer's refrigerator where they can be stored until needed.

Professionals are apt to buy large quantities of slide or negative film, such as 200, 400, or 600 rolls at a time, all with the same emulsion number.

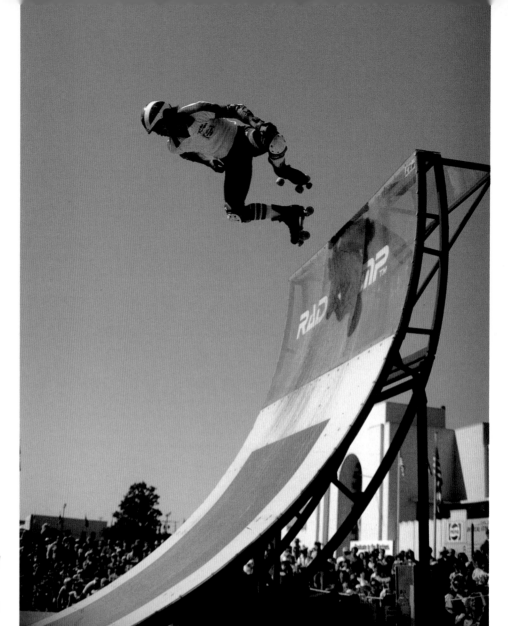

Ray Kennedy photographed a skateboard exhibition at the Texas State Fair in Dallas with an SLR and 50mm lens, the hard way without a zoom lens or a motorized film winder. Even so, at 1/500 sec. on Ektachrome 64 he made a dynamic series of slides of flying skaters. Had he used a faster slide or color negative film, the resulting frozen action and depth of field would have been similar.

Any daylight slide film and all the popular negative color films would be suitable for a bright sun shot such as this portrait of artist Shelley Rapp Evans, who makes soft sculpture of life-size characters. I photographed her with a pair of her imaginative figures at an art fair using Kodachrome 200 (I had loaded it for indoor situations). Flash fill to brighten the shadows would have improved the picture; in strong sun the triple portrait is slightly harsh but realistic.

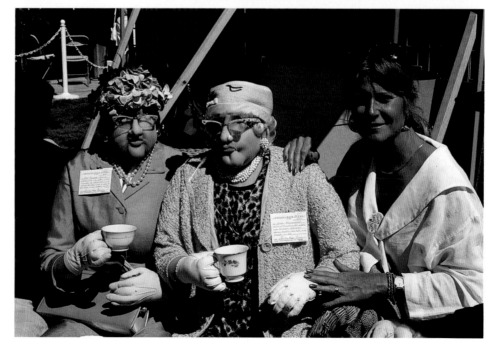

AVAILABLE LIGHT PHOTOGRAPHY

They make tests, keep records of filtration with electronic flash for color slide films, and know they can print color negatives with uniform filtration. Their film may be out of the refrigerator for up to a week at room temperature before exposure and may be processed within another week or two. The result is that the color balance is predictable. But amateurs and many professionals who work on location and don't need the demanding standards of professional films use film with expiration dates up to a year ahead and store them at room temperature to age. If a roll of film stays in the camera for several months and isn't processed for a month or two after exposure, the consequence—a change in color—is not too noticeable.

Color slide films may show the effects of heat, storage time, or delays in processing more readily than negative films, but generally they are very stable. A few summers ago I had a mechanical breakdown on a trip and had to leave my film in the car during a day of hot desert sun. I was concerned enough to have a roll of Kodachrome developed quickly and discovered no appreciable color change. I can recommend that if you take reasonably good care of your film, you don't need the expense or trouble of professional emulsions.

There is also a "Kodak movie film" that is spooled and advertised as 5247 or a similar number by various companies. This is a professional 35mm motion-picture negative film cut into 36-exposure lengths, sold mostly by mail, and processed into slides or prints. The prints may be similar to those you get from other films, but the slides are often not carefully processed. Worst of all, when the film is used to make slides, it tends to fade or discolor within five to ten years. Inquire about the lasting properties of 5247 slides if you're considering using the film to save money. By all means, shoot a sample roll and check the company's craftsmanship.

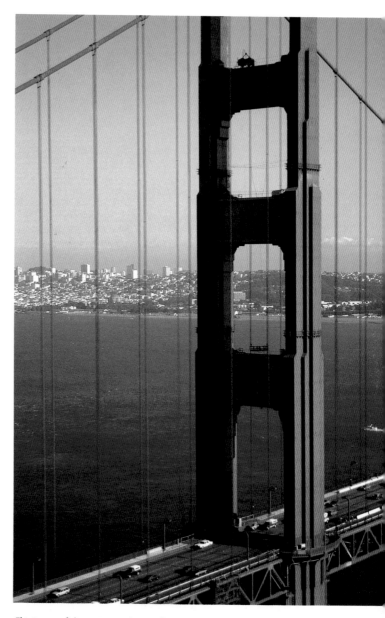

This is one of those pictures that can be a success on either color negative film or slide film. Either way, a well composed and evenly exposed image of the Golden Gate Bridge is stunning. I took this from the Marin County side of the bridge on Kodachrome 64 with a zoom lens.

BLACK-AND-WHITE FILM

Photographers who work in black and white are in a special class. They often value the freedom and control of developing and printing their own pictures. They enjoy the beauty of myriad gray tones between the extremes of white and black. Separation between tones is harder to achieve in black and white than in color, and black-and-white prints require the viewer to imagine color in all those lovely grays. There is a mystique about black-and-white photographs that stems from the 19th century, before there was color. The pioneers of photography and the "old masters" such as Atget, Steichen, Stieglitz, Weston, Strand, and Adams all worked in black and white, and most of

their prints have the capacity to last for 100 years or more. Craftsmanship and artistry in black and white are worth trying to achieve.

Single-lens-reflex users working in black-and-white are apt to shoot ISO 100, 125, or 400 films from either Kodak, Fuji, or Ilford. Kodak Plus-X and Tri-X have been popular for decades, and in recent years Kodak T-Max films rated ISO 100, 400, and 3200 have garnered fans. Fuji Neopan 1600 is much like the T-Max films in that both are convertible films. T-Max ISO 400 film can be pushed to ISO 800; T-Max 3200 can be pushed to 6400 "and up to 50,000 with acceptable results," according to Kodak. Neopan 1600 works well at

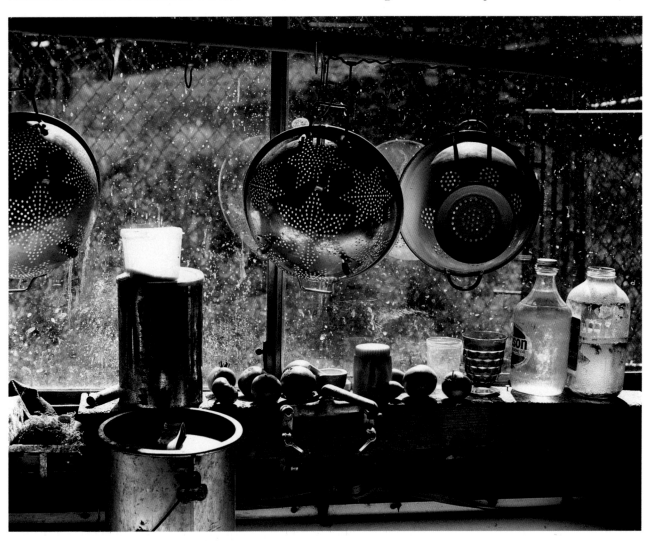

Black-and-white photography is enjoyed by people who want to develop their own negatives, make their own enlargements, and practice photojournalism and fine-art photography. These goals are easier and more fun with films that have finer grain and greater speed for available light pictures. This Oregon canning kitchen was photographed with a 4x5 view camera on Kodak Tri-X with an 8-inch Ektar lens.

ISO 800, 1600, and somewhat acceptably at 3200.

Graininess in prints made from films between ISO 100 and 400 is quite acceptable. Countless photographs that have been published and exhibited were shot on Kodak Tri-X and other ISO 400 films. Tri-X is also an excellent 4 x 5 sheet film for view cameras when it is rated at ISO 320. T-Max 3200 and Neopan 1600 enable you to shoot in extremely low light levels and offer relatively fine grain when exposed and developed carefully. Published tests comparing Neopan 1600 and T-Max 3200 indicate that Neopan grain is slightly finer than T-Max when both are developed in Kodak T-Max developer diluted 1:4 as indicated.

Compared to the very fast color negative films, these fast black-and-white films have finer grain and are adaptable to personal printing techniques. Available light covers a whole spectrum of illumination effects, and black-and-white pictures without flash are always going to be rewarding for those who take the time and trouble. With the high-speed film available, photographers can be less conspicuous than in the past and can thus capture spontaneous images without a powerful flash firing into the subject's eyes.

This photograph, taken with Kodak's T-Max 3200 film and titled "Woman In Memorial Art Gallery," was taken by Bob Clemens. I find it amusing, and here is my guess about how it was taken: Clemens chose T-Max 3200 because the museum galleries were underlit and he wanted to shoot at 1/60 or 1/125 sec. He spied the woman coming and prepared to shoot. She saw him and looked his way momentarily as he pressed the shutter release of his SLR. Blur was avoided because of the fast shutter speed.

UNDERSTANDING EXPOSURE

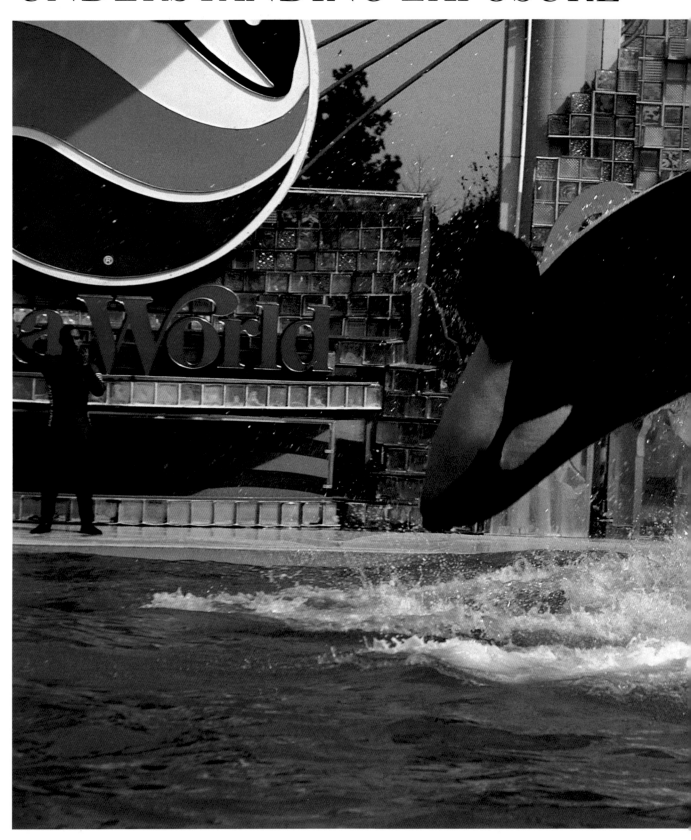

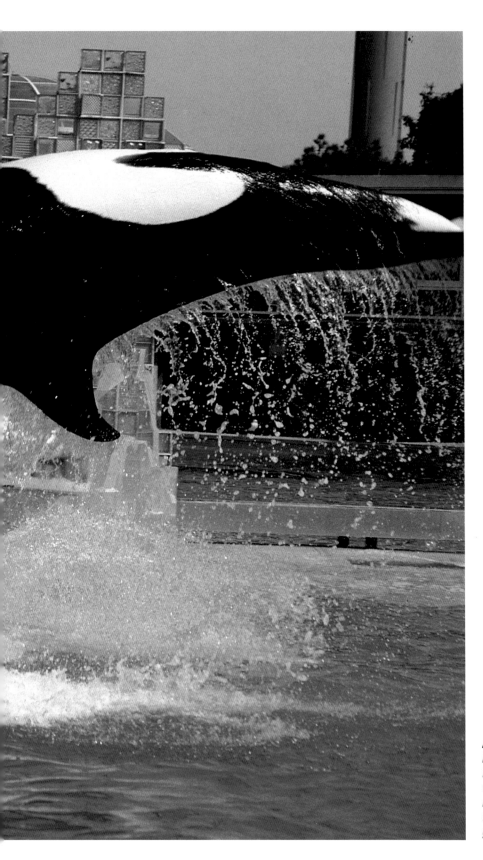

At Seaworld in San Diego, Shamu the Killer Whale hangs in midair, captured at 1/250 sec. on Kodachrome 64 with a 70-210mm zoom lens that weighs only 14 ounces. Most of the scene is middle tones, except for the water highlights and the black whale, and the camera's meter did a good job of averaging this mixture.

HOW EXPOSURE METERS WORK

When I first studied photography decades ago, I really didn't understand exposure theory. Faced with a bright snow scene, I underexposed about a stop because I reasoned that the excessive brightness of the scene needed to be "tamed." If faced with a relatively dark subject, such as someone in a dark brown jacket and hat in front of a dark-toned background, I overexposed one stop to be sure the film recorded all the details. At this time though, I was shooting black-and-white film, processing it myself and making my own prints, so I could manipulate developing and print exposure times. In the struggle for good print quality I actually got away with misunderstanding the reality of exposure theory.

The truth about exposure metering struck me when I began to shoot more color slide film. Mistakes, such as underexposed snow scenes or overexposed dark subjects, were not correctable. It was clear that I really didn't understand how a meter averaged the light reflected from a subject, so I did some test shooting until I understood the concept of averaging. Later, when I switched to an autoexposure camera, I found that I still had to make some manual exposure compensations for predominately dark and bright subjects. Even today, in a camera with four or five built-in exposure modes, the internal exposure meter still only averages reflected light (although multi-pattern metering systems do offer more versatility and precision).

Basically, an exposure meter collects the light reflected from a scene and averages it into a single tone, or what is more commonly known as 18 percent gray. In other words, the meter responds to highlights, shadows, and middle tones, and blends them into an average 18-percent-gray tone. Regardless of the overall brightness of the setting, the meter gives a reading for all the subject tones combined as a single exposure. The meter then takes that measurement to set a "correct" exposure for the film speed in use.

Lewis Portnoy photographed a show by employing stage lighting and used a spot meter to read the exposure. He aimed the meter at a striped skirt that he knew would be near an average 18 percent gray. If he had read the entire scene with all its black background, the meter would have indicated an overexposure reading.

Both vertical and horizontal scenes can be read for exposure by today's camera meters. At this Alabama pond, the tones were easily averaged into 18 percent gray for a perfect exposure. The bright sky area was small and didn't influence the exposure toward a darker image. You can learn to sense when lighting and subject contrast in a scene is average.

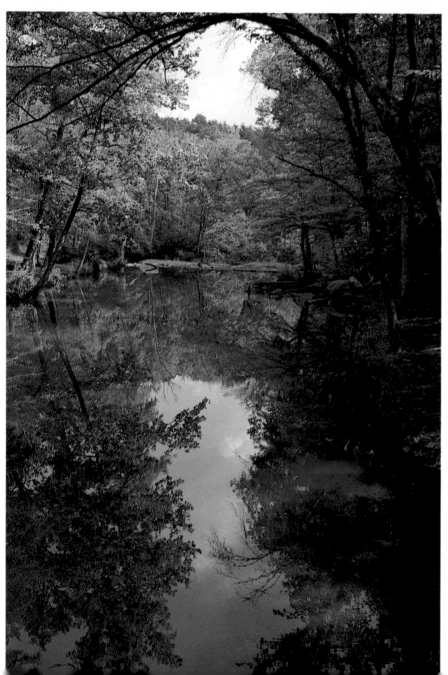

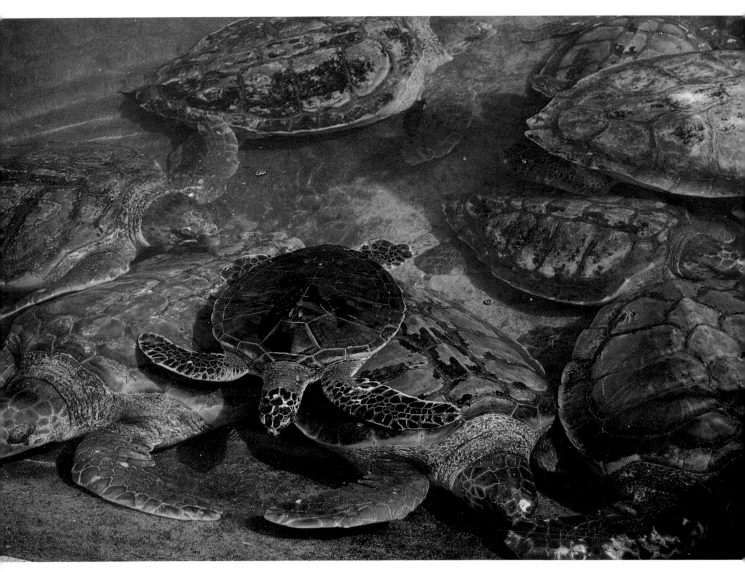

Sea turtles in bright sun were a low-contrast subject that would have been excessively lightened if I had used an average exposure. So I stopped down 1/3 and 2/3 of a stop (bracketing is covered on page 58) and chose the latter exposure here. By using the exposure compensation dial on my SLR, I made a well-exposed slide on Kodachrome 64. Exposure compensation is good practice with color slide film and is optional with color print film because tonality is usually adjusted during printing.

You can buy an 18-percent-gray card in a camera shop and test this meter response yourself. Point your camera at the card, placed in the same light as your subject, and take a meter reading. Make sure the card fills the viewfinder and be careful not to throw a shadow on it. Remember the exposure from the card, take it away and read the subject itself. If any adjustment is needed for bright or dark tones, usually it will only be around a half stop. By all means, shoot some comparison prints or slides. Using slide film quickly helps you become more aware of how a meter averages reflected light; because, while exposure variations can be corrected to some extent in color prints, slides are unchangeable.

With a spot meter, either handheld or built-in on some camera models, you can actually measure a 1-degree angle, or 2 percent, of the entire image.

This can be helpful in situations where you want to pinpoint important areas of the image and expose for them, thereby bringing out all the detail in that particular area. It also comes in handy when working at great distances or in high-contrast situations where a typical averaging meter would be almost useless. For instance, while photographing a stage production with brightly-lit players and dark backgrounds, an overall reading is hard to interpret. With a spot meter you can read exposure on one face or shirt and expose accordingly.

Most pictures can be exposed using the average meter reading with today's films, but photographers should recognize two exceptions. If you were to photograph a snow scene or a beach with lots of bright sand, the reflectance would be around 90 percent. In bright sun a meter would blend, or average, that light to make sure the snow or sand had a middle-gray tone and would thus underexpose the image. Under those circumstances black-and-white and color negatives can often be used to make good prints even with some overexposure. But when reduced to 18 percent gray, predominately bright scenes will be too dark on color slide films. You would then have to manually adjust to avoid overexposure by opening the lens 1/3 to 1/2 stop, thereby restoring good color saturation to slides. This is done by using the camera's exposure compensation dial or setting the lens half-way between f-stops. You may also reduce the ISO setting by 1/3 to 1/2 stop on cameras with a manual film speed setting. Resist the tendency to stop down the lens when a bright subject dominates the picture, no matter what film you're using. Shoot some comparison test pictures with and without any compensation, using an 18-percent-gray card as an exposure guide. You'll see how exposure theory relates to picture quality.

When you're photographing predominately dark subjects, the opposite effect can be seen. As an example, place some dark-covered books and a dark hat on a dark background. In shade or sun the reflectance would be less than 18 percent but the meter averages the tones to 18-percent gray, making the subject brighter and thus overexposing the picture. Again, black-and-white and color negative films may do okay with averaged exposures, but color slide films will end up being somewhat washed out. Resist the urge to open the lens wider for predominantly dark subjects, but compensate by stopping down 1/3 to 1/2 stop, depending on the subject, for better color saturation.

Intentionally underexposing 2 stops gave this New York street scene a sense of drama it wouldn't have otherwise had. The meter said 1/125 sec. at f/8 and I set the 35-70mm zoom lens at f/11 and f/16. One stop underexposure at f/11 was okay, but two stops at f/16 was more striking. The film was Kodachrome 64. Similar underexposure with a color negative film wouldn't have been as successful because prints made from severely underexposed negatives often look muddy.

PROGRAMMED EXPOSURES

On many automated camera dials there is usually a "P" setting for "program," meaning that the f-stops and shutter speeds are locked together in a functional progression. In this setting, both shutter speed and aperture are adjusted automatically according to the light intensity. The program, like the exposure system of a point-and-shoot camera, tries to choose a fast-enough shutter speed to avoid camera movement and catch the action sharply, while at the same time providing a small enough aperture for adequate depth of field. Various forms of programmed exposure are found in different camera brands. Programming is an automation that allows you to be instantly ready for taking pictures, especially with cameras equipped with autofocus.

In the past, most SLR cameras used aperture-priority exposure systems, where the user chose the f-stop and the camera's internal meter determined the shutter speed to match for correct exposure. A few SLRs used the opposite shutter-priority system where the user chose the shutter speed and the camera chose the aperture. Both systems had their advantages. Aperture-priority photographers preferred control of the depth of field. Shutter-priority users claimed that control of the shutter speed was essential for sharper pictures that might otherwise be missed.

Programmed exposure blurred the arguments about which exposure system was more convenient. With the camera's electronic combination of *f*-stop and shutter speed for each light value, all the photographer has to do is set the film's ISO number. But does the programmed meter know when you should make exposure compensations? And how does the photographer cope with the meter's tendency to average the light into 18-percent gray? The answer is to be aware of bright and dark extremes and use the exposure-compensation dial or switch to manual exposure and make your own judgments. Many cameras offer both aperture and shutter priority modes as well as program mode plus exposure compensation. Thus the photographer can switch from programmed to another mode, make exposure compensations for predominantly light or dark scenes, and get slides with proper color saturation. Smart photographers also adjust exposures when shooting negative film to be able to make prints without too much manipulation.

What about exposure compensation with point-and-shoot cameras? Well, few, if any, of these cameras offer exposure compensation because most of the controls are fully automatic. These cameras are basically designed for negative film so that any exposure control can be done in the printing process. Fully programmed automation obviously works, but it does diminish the number of creative steps a photographer could take with other more adjustable cameras. Being able to freeze time with a high shutter speed and blur action with a slow speed are delightful aspects of photography. If your camera is completely programmed, you may not know when you're shooting at a shutter speed too slow to handhold the camera or at an f-stop that offers too little depth of field. Add autofocus to the goodies built into a camera, and you relinquish even more control.

Fortunately, in many point-and-shoot cameras the flash is self-activating in low light levels, and exposure compensation or correct focus are not matters of concern. If you use a programmed camera—an SLR or a point and shoot—read the instruction booklet thoroughly. Be familiar with its slowest and fastest shutter speeds, and get to know the largest and smallest apertures of each focal length. The more you know, the more aware you'll be when the light changes and you need some camera adjustments.

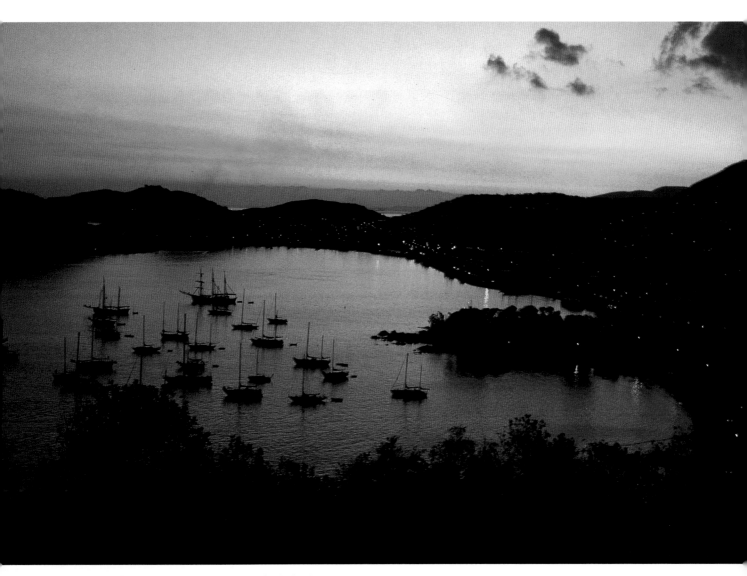

Sunsets are easy subjects to expose, depending on how bright the sky is. Ray (Bud) Kennedy shot a programmed exposure first and then made some personal adjustments. He knew that when a dominant sky is very bright and you want to hold detail, the meter-indicated exposure will slightly underexpose the foreground. If foreground detail is worth showing and the sky dominates, open the lens half a stop. Kennedy preferred this programmed exposure with its darker foreground when he compared slides.

CONTRAST

One of the confusing concepts new photographers
face is the distinction between photo contrast and
dominant tonality in a scene. For example, you're
visiting an amusement park (or almost any outdoor
location) on a bright sunny day, and you want to
shoot some people dressed in dark clothes standing
against a white structure. The contrast between the
two is considerable. The camera exposure meter
may read the dark subject in the scene at 1/60 sec.
at f/4 and the white building at 1/250 sec. at f/11.
That is a difference of five stops. Most films can
handle that contrast range without problems, but
how do you expose for contrast extremes? With
programmed or point-and-shoot cameras, you can
use the meter's average; if you're using color
negative film, you're likely to get sparkling prints.
The same applies to adjustable and automated
SLR cameras with either negative or slide films.
Meters are usually very good at averaging extreme
contrast tones and producing a middle tone of 18
percent gray. Only when light or dark subjects
dominate the image do you need to outguess the
meter and make manual exposure compensations.

If you want more detail in bright or dark
subjects, you can manually adjust the exposure for
them. Remember, in doing this you might drown
out the other tones in the scene; with
underexposure you lose shadow detail, and
overexposure wipes out highlight detail. Keep in
mind that your meter averages very well in a
majority of situations, even when color and tonal
contrast is high. Try to keep a record of baffling
exposure situations so that in the future you'll
know instinctively if you need to make
compensations.

Another method exists for dealing with outdoor
contrast. Using a polarizing filter in bright light will
cut contrast by controlling the reflective scatter of
light. Rotate the filter on the lens until you see the
effect you want in the finder; then shoot. Polarizers
reduce the light intensity by about 1.5 stops, and
sometimes subtle color tones will be affected.
However, outdoor exposures with a film rated at
ISO 100 or faster will be suitable even with the
light lost through the polarizer. You can easily
preview through the polarizer and decide if it is
worth using. Finally, when contrast is high and you
want brighter shadows, use flash fill or a reflector.
Many cameras do a great job with fill-in flash by
automatically regulating its intensity so that
shadows are illuminated to just the right tonality.

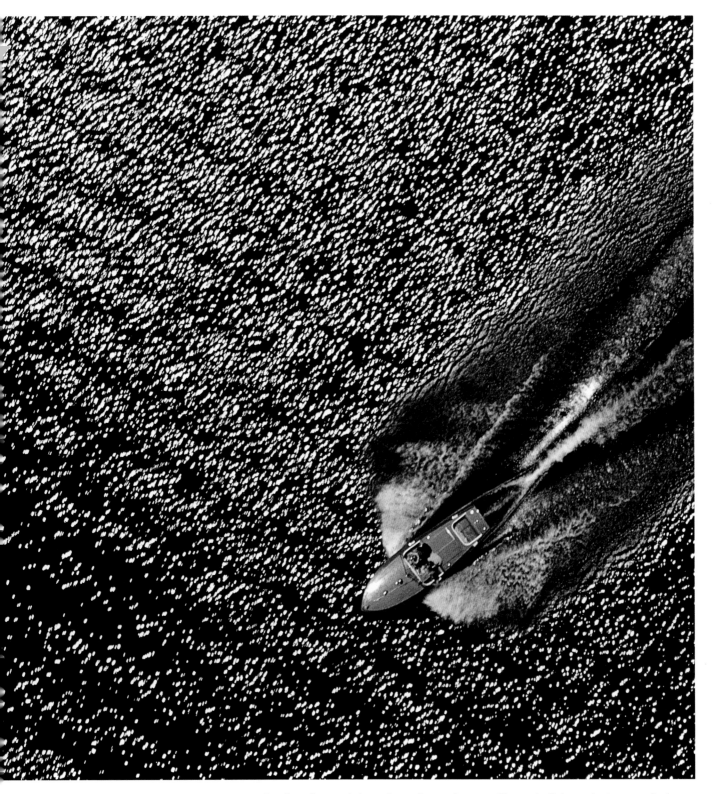

Seen from above, sunlight at a low angle created a carpet of lustrous highlights on the tiny waves sliced by a speedboat. Jay Maisel photographed it with a motor-driven SLR from a helicopter, bracketing several times though the normal meter exposure was right on. The bright water caused a slight underexposure, which is what Jay wanted to retain good color saturation.

I admired the young woman's tatoos when we were both visitors at an art museum, and she agreed to my request for a few pictures. I chose a spot where sun came strongly through a window and illuminated her back like a spotlight. The meter tended to average a slight underexposure because of the bright sun, but that was to capture detail in the tatoos. I used a 50mm lens on a 35mm SLR with Kodachrome 64.

The contrast in the view from this porch held up, though the light was subdued. I used a 35mm SLR on a tripod with a skylight filter over the 35mm lens and exposed the Kodachrome 64 film according to the meter's average. At f/11 the depth of field was good. Although the shutter speed was 1/15 or 1/8 sec., the fine rain disappeared in this image.

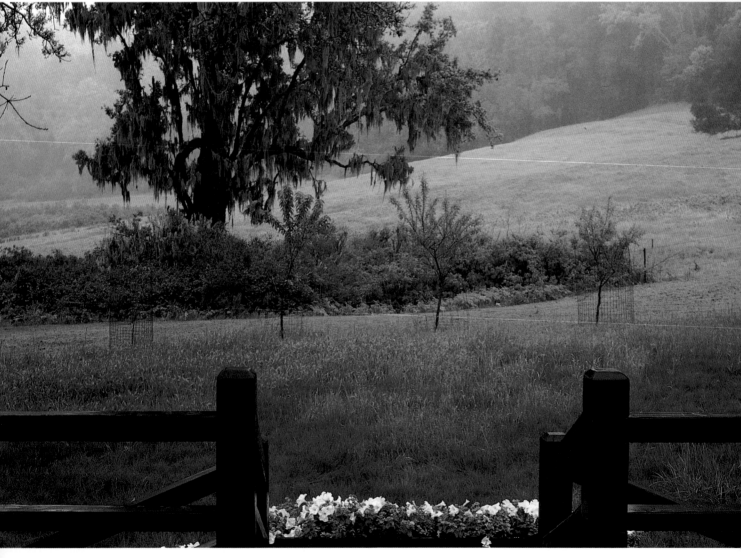

AVAILABLE LIGHT PHOTOGRAPHY

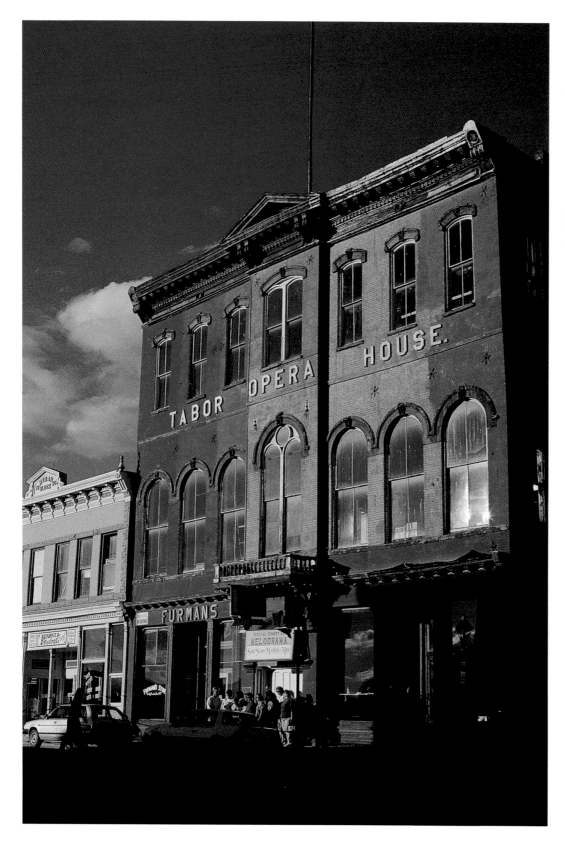

In Leadville, Colorado, at about 7PM, I delayed dinner plans in order to photograph some of the main street which I hoped would glow in the evening sun. The appearance of a group of people was coincidental and helped enliven the red-brick opera house. I used Kodachrome 200 and a polarizing filter.

BRACKETING

Bracketing comes in handy when you're not really sure how to expose a certain subject and you just want to get it right. First you take a shot at the recommended exposure given by the camera's meter or an external meter. Then shoot several more exposures of the same subject at one-third or one-half stops over and under the first one. By experiment you'll learn which increments work best for you and your equipment. Color negative or black-and-white film can handle a full stop better than color slide film. For example, if the meter reads a certain image as 1/125 sec. at f/11, then you take the shot and follow with pictures at f/9 and f/12.5 also at 1/125 sec. These settings are half-stop detents between the marked stops on many lenses. You could also bracket by setting the camera's exposure compensation dial for 1/3 or 1/2 stop increases or decreases.

A few automated 35mm SLR cameras offer automatic bracketing whereby the camera takes three or more quick frames of the same subject at varying exposures. Bracketing can be a form of insurance in a tricky exposure situation. If you're not certain whether bright subject matter or dark subject matter dominates a scene, overexposing and underexposing may give you slides or negatives that are better than if you merely shot at one exposure. You'll know looking at slides if they are too light or dark, but good prints can often be made from improperly exposed negatives. Examine your negatives and note the variations in density or opacity. Sometimes you'll see detail in a negative that's obscured in the color print; you can send it back to the lab for improvement.

It helps to be thoroughly familiar with your equipment and trust it. I don't bracket very often because it seems unnecessary when I understand how an averaging meter works. I do bracket or make exposure compensations when experience shows the subject requires it or if the picture may be especially saleable. For example, I once photographed a scene of tall, sunlit rocks with shadowed trees and a reflecting stream in the foreground. I was using slide film, and I bracketed 1/3 and 2/3 stops both over and under the recommended exposure. With added exposure, the stream was brighter, but the rocks lacked any detail. With decreased exposure, the rock detail was better and the stream, while still dark, showed up okay. With slide film I am less likely to increase exposure, a tactic more appropriate for color negative film. Try bracketing for a while and you'll have a better understanding of when it may be useful and when it is not.

In tricky exposure circumstances, bracketing can help assure a correctly exposed slide or negative, though color negatives offer more latitude than slides. For this closeup of bougainvillea, the overall meter reading (f/11 at 1/125 sec.) used to take the middle picture was correct, but I wasn't sure if the meter would be overly influenced by the bright flowers or the dark background. I exposed the picture on the left at 1 stop over the meter reading (f/11 at 1/60 sec.), and the picture on the right at 1 stop under the meter reading (f/16 at 1/125 sec.). Bracketing at half-stop intervals is also useful depending on the subject contrast. You decide which you like the best.

THE DIRECTION OF LIGHT

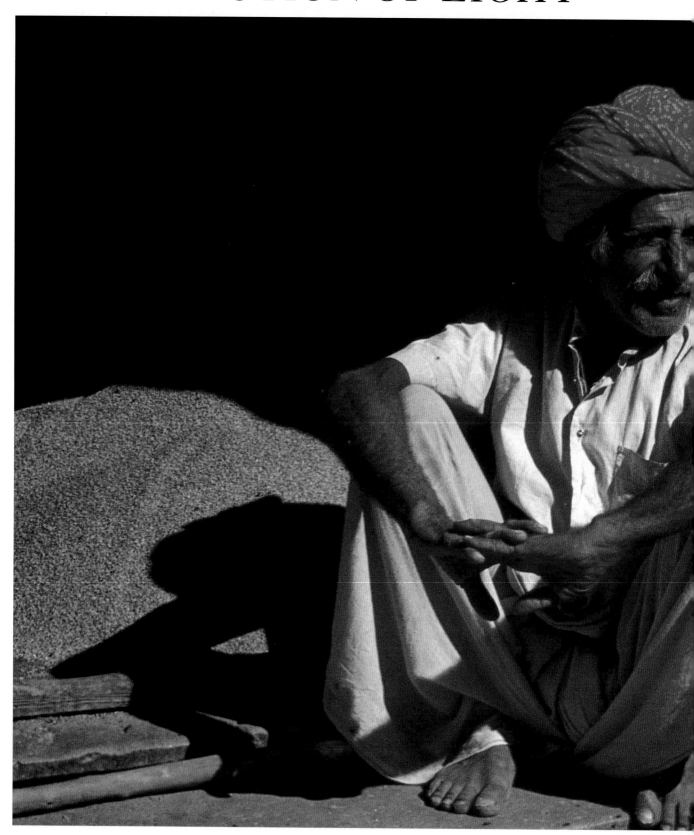

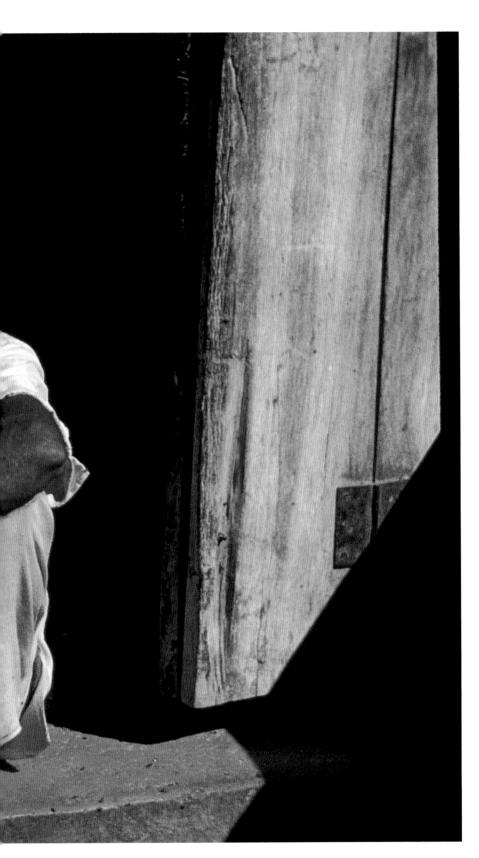

Tom Atwood knew that the strong sidelighting he found in a small town in India was just right for showing people in their environment. To maintain distance from the subject and assure the visual impact of the moment, Tom used a right-angle lens over his camera lens. The right-angle lens acts like a small periscope allowing you to face one way and focus on a subject 90 degrees to the side. Hence the man was not self-conscious, and authenticity prevailed. Tom used a 105mm lens and Fujichrome 100 film in his SLR.

DIFFERENT ANGLES, DIFFERENT MOODS

Without light, photography would be impossible. Light illuminates the subject and—by its direction, intensity, and color temperature—creates the mood of a scene. When you plan a picture, in addition to being concerned about the impact and content of the image, imagine what effect light has on these qualities. Ask yourself, "Why should I take this picture?" There are many answers to this, most of

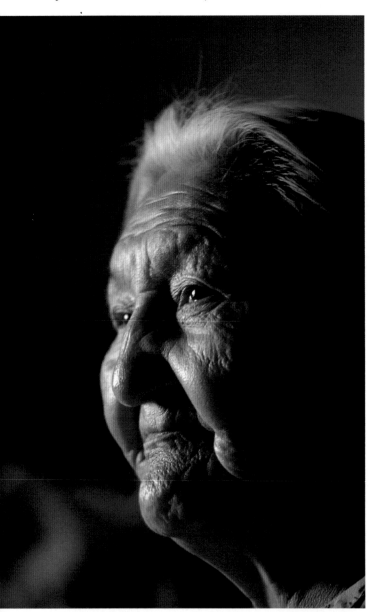

Jim Cook, a Denver professional, photographed Ruth Black Bear at Wounded Knee, South Dakota, as part of a personal project. At age 71 she is a fourth-grade teacher and is shown here sidelighted by a window in her home. Jim used a 28-80mm zoom lens on an autofocus SLR and Kodak Ektachrome Professional 64. This portrait has dignity and clarity. Jim handheld the camera at a slow shutter speed, but I'd recommend using a tripod.

which you run across each and every day: to capture the mood or mystery of a scene; to photograph your son or daughter playing an exciting game, hopefully in attractive light; and to preserve the image of someone in a warm, reflected light. Photographic goals are many and varied, and the quality of light employed affects the outcome of all of them.

Expect to shoot lots of pictures where the light enhances a commonplace subject, making it warm, soft, strong, or moody, but always ask yourself if the subject is otherwise interesting. You may have heard a photograph described as "painterly"—suffused, soft-edged, and airy as a landscape by Monet, or intensely focused with dramatic chiaroscuro like the religious paintings of Caravaggio. The technique and structure of a painting are determined by the painter's concept of light, and study of the treatment of light in paintings as well as photographs can contribute to your style. The ability to appreciate the visual consequences of changing light can boost your spirit and increase your success with a camera.

To decide if the light is right for your pictures, first ask yourself a number of questions: Does the direction and character of the light help delineate or does it obscure the subject? Is the light too flat, and does the subject lack shadows? Should I have been there an hour earlier, or should I wait another hour? Is the light bright enough to handhold a camera, or do I need a tripod? Should I use a tripod anyway for greater sharpness and more studied composition? Are there confusing shadows on someone's face? Should I find a softer light? Does the picture need flash-fill or a reflector? A good piece of advice is to take risks. The "right" light is a subjective term, and you may not know what is just "right" until you see your slides or prints.

While traveling, when the light is right and looks like it will stay that way, photographers may have one of two attitudes. Some professionals who have the time prefer to explore the area, climb stairs, or view subjects from different eye levels before they take any pictures. That would frustrate me because I'm usually pressed for time when I travel, and I shoot the possibilities as I explore. However, I think carefully about why I'm making each exposure. Although the light is not always ideal, I may not be back in the same spot soon, and film is relatively cheap. Occasionally I must rationalize to find a reason to shoot each picture, even if it is only "because it's there."

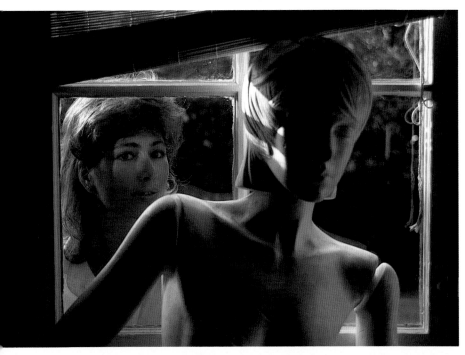

Backlighting creates the drama in this mysterious situation. The girl's face is partially lit and the manikin's face is strongly shadowed. The mystery in the relationship was planned. Lighting accentuates the unknown because the shadow areas are so important. My SLR was loaded with Kodachrome 64, and I used a 35-70mm zoom lens.

During his tour of photogenic places around the world, Jim Nikas III photographed impalas in Masai Mara, Kenya, using an SLR with a 200mm lens and Fujichrome 100 film. The camera was on a tripod and Jim added a 2X extender to the lens, making it a 400mm. The sun shines evenly from the top left and shadows separate the animals from the grass in a pictorial way. With such a long focal length, depth of field is shallow, even at f/11.

THE DIRECTION OF LIGHT

For a better grasp of photographic light and the effect of its direction on a subject, shoot an exercise outdoors. Choose a model that you can move around to change the light's effect, or arrange a still life on a sheet of illustration board so you can rotate it on a table top. Still life material should have both sharp and soft edges for a variety of shadows. Find a simple outdoor background and pose your model on a stool or set up the still life on a table with plain background. Mount your camera on a tripod and use a lens between 50mm and 100mm. Now, experiment with the different directions of light by moving the subject or waiting for the effects of different times of the day. You may be surprised to find that a mere change of camera angle can completely alter the mood of the set up.

Front and top lighting often create images that look flat or washed out. This may be an advantage when you want to understate a subject, but stronger directional lighting is usually more pictorial. Turn the model 45 degrees and watch the shadows become more interesting. A medium-high, 45-degree light, the kind you get about 10 A.M., is delightful for some scenic shots and for classic portrait lighting. Use a 20 x 30-inch or 30 x 40-inch sheet of white illustration board or a photographic umbrella as a reflector to brighten shadows. Sidelighting often helps to increase drama and contrast. If the sun comes from slightly behind the subject, it can also create a welcome edge-light to dramatize the subject. When the sun comes from behind a model or still life, shadows are increased and the strong contrast wipes out any detail in the shadows. It might help to fill in the shadows close to you with a reflector or flash-fill. To expose for backlight without any fill, try 1/2 to 1 *f*-stop larger to brighten shadows. Usually shady areas or cloudy days are best for portraits or still life. Indirect light creates only faint shadows, and form is better in stronger light, but there is beauty in soft subtle light. Examine the prints or slides you take for this exercise, and compare how different directions of light affect the mood of the image.

Front and top lighting

45-degree lighting

Sidelighting

AVAILABLE LIGHT PHOTOGRAPHY

Backlighting

Indirect lighting

LIGHT FROM ABOVE

Front and top light are usually not the most exciting types of light, but if they are high enough, the shadows they cast can give form and dimensionality to landscapes. Shadows are the key to lighting direction and often the key to good photography. Shadows from toplight help show off forms and textures, and they offer visual accents. High toplight is usually unflattering for portraits because it causes facial shadows, dark eye sockets, or squinting, but it works well for other subjects that are outdoors. Sometimes you can just change camera positions or move the subject, horizontally or vertically, and front or top light becomes more pictorial. However, summer sun at high noon is okay for buildings, and may describe the forms and outlines of sculpture extremely well.

Jim Nikas III, travelling widely to shoot stock photographs, found this swallowtail butterfly on a flower in Seven Star Park, Guilin, China, at a time before the student uprising. There were faint clouds over the sun when Jim handheld his SLR loaded with Fujichrome 100 for this impressionistic shot.

Off the coast of New Guinea the fish were jumping and the sun was high as Jay Maisel captured the scene with characteristic simplicity. All his pictures were taken on Kodachrome with an SLR and a variety of lenses. Says Jay, "I collect events of light and relationships of time, people, and places that will never be exactly the same again."

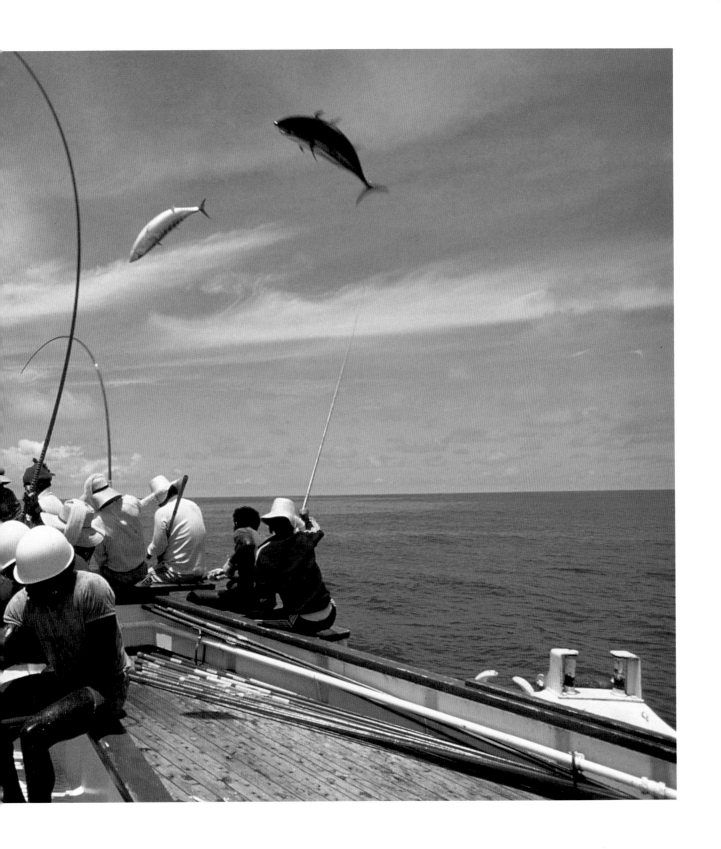

THE DIRECTION OF LIGHT

45-DEGREE LIGHT

For strong scenic pictures, try to catch the sun at a medium-high, 45-degree angle. In a studio, 45-degree lighting is popular for portraits, with fill light usually reflected into the shadows. The same applies outdoors if the light is not too harsh. There are endless variations in nature, in the city, or in rural situations. When you have choices about camera position, try as many as you can. If you have time—and no alternate viewpoint—and you want 45-degree light, wait for it to change. Pictorial impact varies as light and shadows change. If you come upon a scene in midday hours and realize that the light at 4 p.m. will have more of an impact, wait around and shoot other things until then. As the light approaches 45-degrees or lower, the scene will probably change drastically, warming in color and tone and becoming more dramatic as the shadows grow longer.

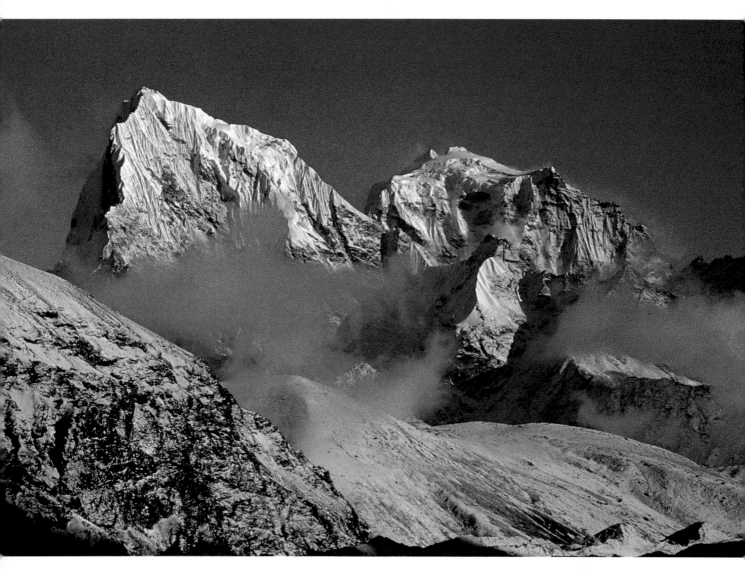

A mountain in Nepal not far from Mt. Everest was in bright sun when Tom Atwood arrived with his SLR, a 70-210mm zoom lens, and Fujichrome 100 film. "I was fortunate," he said, "to find thin clouds blowing through because this area is often so cloudy that you can't see mountains." Light from one side gave beautiful form to the jagged peaks.

In Colorado, Bud Kennedy found an ancient mining structure surrounded by pines bathed in 45-degree sunlight and made a lovely scenic using Ektachrome 64 film in his SLR. He used a 200mm lens with a 2X extender to make the focal length 400mm. Bud shot from a tripod because the smallest camera movement with a long lens can blur an image. Many old lens extenders were optically inferior; the best ones made today cost more and include very good optics for sharper images.

AVAILABLE LIGHT PHOTOGRAPHY

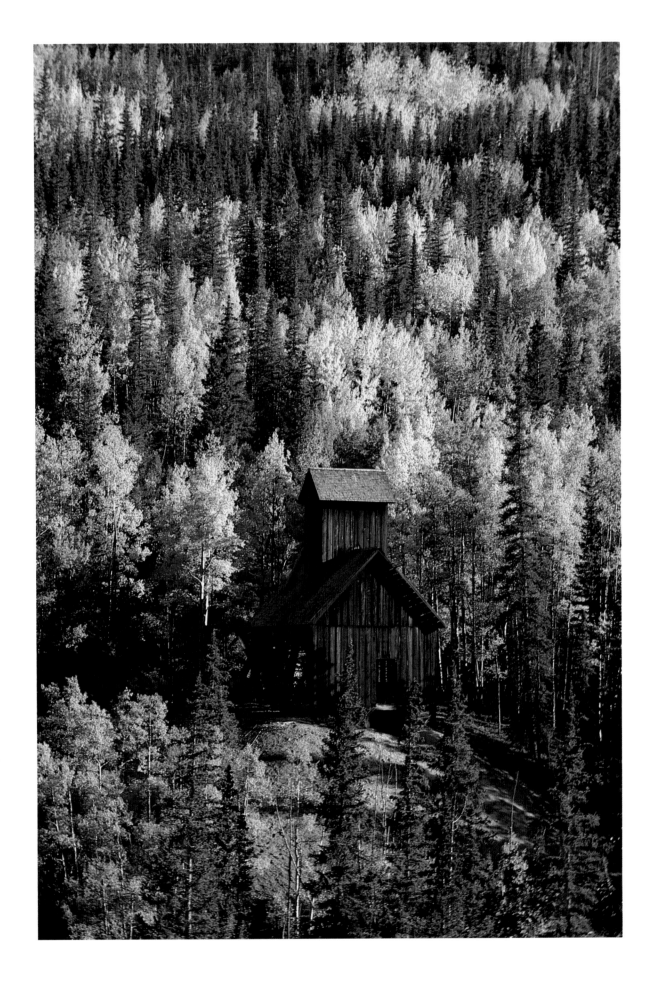

THE DRAMA OF SIDELIGHT

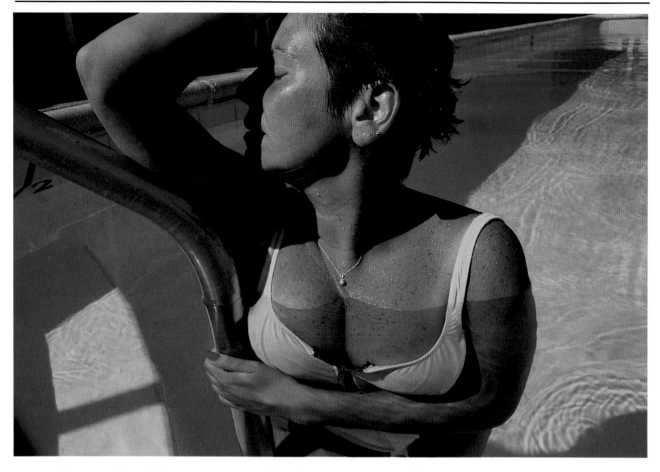

Here is another situation where sidelighting produced a pictorial effect more attractive than any other lighting could have done. A friend and I were swimming when I realized how beautiful the light was becoming; so I dashed home for my SLR and 28-80mm zoom lens. The colors and the design of the shadows in the composition combine to give the image impact.

Front and 45-degree lighting are practical and may be beautiful on some subjects, but sidelighting is often the most dramatic and glamorous angle of light. Images of subjects in sidelight are almost certain to catch your eye, even if some of the detail in the shadows is lacking. A photographer's personal style is not going to depend on sidelighting alone, but when the sun illuminates from the side, images tend to have a distinguished visual character.

Sidelight is the most useful type of light when texture is important. The shadows given off by the subject are what show the relief of the surface or the distinctive characteristics of its shape. Sidelight also creates a sharp contrast between the lit side and the shade. Shadows may be long and sometimes increase the drama of the photograph. This type of light is also wonderful for closeups when you want to accentuate the texture and any small changes of form, important considerations when you're within inches of a subject. Often the effects of sidelighting are so strong and attractive that you can expect some striking visual images.

The Bisti Wilderness of northwest New Mexico is one of Eduardo Fuss' favorite places, and he planned to be at this scene half an hour before sunset to shoot the "strong sidelighting and long shadows." Eduardo used a 35mm SLR with a 28mm lens and Kodachrome 25 for an impressive picture that resembles the surface of the moon seen in NASA images. A tripod allowed him to shoot at a small aperture and slow shutter speed. No other kind of light would have been as appropriate for this situation.

THE DIRECTION OF LIGHT

BACKLIGHTING

In a photographic studio, backlighting is the accent or glamour light used mostly for portraits or still lifes. Fill light is added to brighten shadows which are usually a major part of the image. Backlighting is also a favorite way to make food look more appetizing and architectural interiors more appealing. Light from behind a subject and often slightly to one side or the other helps separate it from the background and adds emphasis when the background is messy.

In the world of natural light, backlighting may glamorize a subject, animate or inanimate, but the sun has to be at the right angle to outline a face or figure, glance off snow or pavement, or brighten the surf where silhouetted children play. In a back-lit situation when you want the shadowed area to remain a silhouette, expose for the bright area and let the color and tones in the rest of the picture fall into place. If you are photographing an individual or a group, exposing for the backlight will usually make the faces and figures too dark. Either open the lens one *f*-stop, slow the shutter speed one stop, or use flash fill. The backlighting effect will still be there, and the most important areas of the picture will be detailed. Some modern cameras can add flash fill and adjust exposure automatically to brighten shadows properly, but this can often be done with an exposure compensation dial or mode.

Backlight is a favorite photographic light, and Lewis Portnoy was ready when an athlete gestured her desire to win a track event she was about to run. Edgelight, a form of backlight, is glamorous and in this picture separates the subject from a background that is soft and unobtrusive because Lew was shooting with a 300mm lens. The longer the focal length of a lens, the less its inherent depth of field at a given aperture, and Lew knew that at f/4.5 the lens would make the background anonymous.

Here Lew knew that edgelight would handsomely separate the horse and rider from the background. He shot with a 200mm lens on his SLR using Kodachrome 64 and exposed 1½ stops less than the meter reading to darken the whole picture and accentuate the edgelighting. "It was one of those pictures you shoot because the light and the subject complement each other so well," he says.

Backlight on the beach at Carmel, California, came from the western sun in late afternoon, dramatizing the boys playing with seaweed in the surf. I focused on them with a 70-210mm zoom lens and shot half a dozen frames on Kodachrome 64, using a 1/250 sec. shutter speed. I made no exposure compensations, realizing the bright surf would make the kids go dark. I like their balletlike pattern but was surprised at the monotone effect the backlighting created by neutralizing the color; the picture looks like a tinted black-and-white photograph.

THE DIRECTION OF LIGHT

OVERCAST LIGHTING

There are pictorial differences between certain related lighting conditions. A bright overcast sky, usually bright clouds or open shade, can make beautiful light, may soften color into pastels, and can give you detailed shadows. A heavily cloudy or rainy day can help make a moody subject, but such days are usually irritating when you're traveling. And sunlight reflected into a shady area may have soft brilliance and satisfying contrast.

Hazy sun and shade or reflected sunlight are all beautiful for portraits and can create atmospheric pictures. Many of the portraits in magazines, both editorial or advertising, are either shot outdoors with indirect or reflected light, or in studios with carefully controlled reflected electronic flash. Large studio reflectors and clusters of diffused flash units create the effect of a slightly overcast day, perfect for softer and more saturated colors. Studio photographers imitate natural lighting without having to wait patiently for weather to change or without being dependent on chance discoveries of beautiful light.

The color temperature of the light in shade and on a cloudy or rainy day is cooler than in sunlight. Shooting slide film, use a skylight filter to tint the light and warm your pictures. The effect of a skylight filter is subtle and makes color look "healthier," you might say. Don't worry about variations in color negative film; the color can be warmed easily when prints are made. If you're lucky to find a shady location where the sun is reflected onto the subject to fill in the darker areas, the results can be lovely. This is the type of light that studio photographers create with electronic flash and large diffusers. Around home, you can use a sheet of white illustration board as a portable reflector. Ask someone to hold it at the right angle, or mount it on a light stand by piercing a hole at one end of the board. A photographic umbrella handheld or clamped to a light stand is also a good reflector. On the road, you might carry a folding sheet of white cardboard or you may find natural reflection in a shady area. Try shooting portraits in overcast or indirect light; the light is much softer, which often makes the subject look terrific.

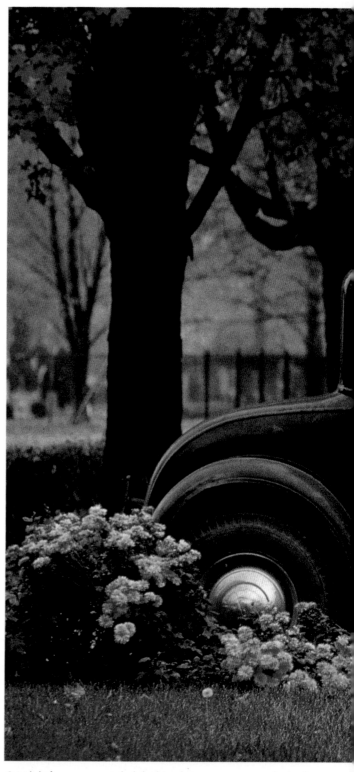

Quiet light from an overcast sky helped Angelo Lomeo, a veteran professional, give a Model A Ford the air of nostalgia he saw in the scene. Lomeo and his wife, Sonja Bullaty, work together, but each brings a distinct vision to travel and nature photography. Lomeo is a great admirer of painter Edward Hopper and says Hopper's use of light was a strong influence on him. He sees any landscape as a challenge simply because of the constantly changing light.

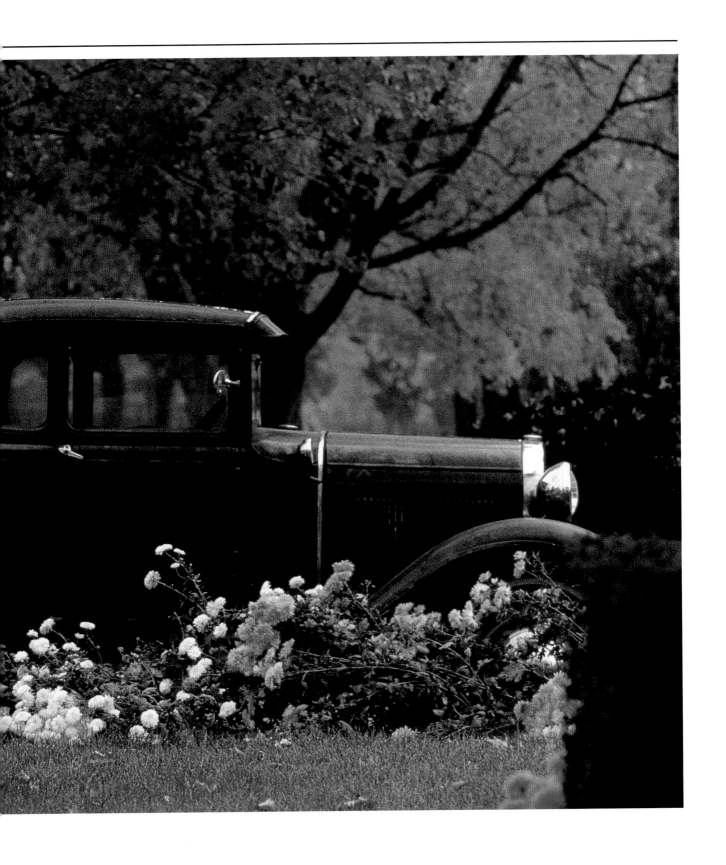

DAYLIGHT OUTDOORS

Jay Maisel studied painting before he became a
photographer, and it is apparent, especially in his
sense of composition and color. He is known for
his ability to extract the essence of a scene or find
a viewpoint that features important pictorial
elements without distractions. Jay avoids filters
and manipulation, but he does bracket many of his
exposures in order to get ideal color saturation
with Kodachrome.

THE UNIVERSAL LIGHT

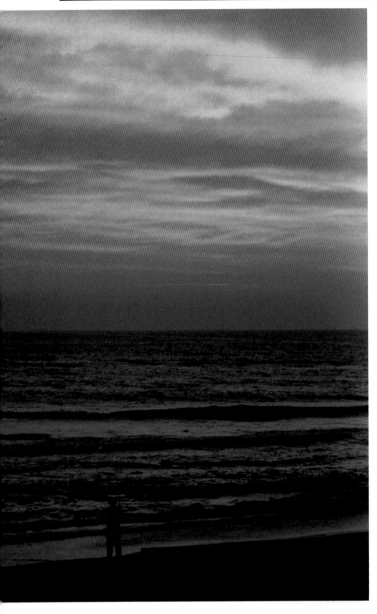

As a judge for many photographic contests, I know how popular sunsets and sunrises are as subjects for serious amateur photographers. To be successful, a sunset picture should have dramatic clouds and color and perhaps something interesting in the foreground for visual impact. Any type of film can give you beautiful pictures of a sunset or sunrise, and exposure manipulation is virtually unnecessary. This was taken on color negative film and made into a slide.

In sun or shade, daylight can be beautiful, extreme in contrast, subtle, directional, flat, or frustrating. In parts of the American Southwest there are more than 300 days of bright sun a year. But in the Northwest and the British Isles, photographing on a cloudy or overcast day is common. Wherever you travel, learn something about the kind of light indigenous to a certain area so you can plan good shooting times and bring the right film.

Despite the diversity of lighting conditions in the world, I think most of us would agree that "good light" is directional and has enough contrast to show form. It also has to be soft enough for portraits, intense enough to shoot fast action sharply, and warm enough to tint the landscape golden at sunrise and sunset. Good light is bright enough to make exposures at the right *f*-stops for good depth of field and at shutter speeds fast enough to handhold the camera. Beautiful daylight may also be so weak that you need to use a tripod.

The angle and quality of daylight often dictates how you compose a picture and when you can shoot. Photographing around home, you can afford to wait for the light to change. On the road though, you may have to shoot under clouds or in the rain. Professionals prefer to shoot landscapes and cityscapes from sunrise until 10:00 or 11:00 a.m., and from 3:00 or 4:00 p.m. to dusk, depending on the season and on local weather conditions. One travel photographer told me that over the years he realized he couldn't shoot in the Alps in the morning because the fog doesn't burn away until the sun is high. The same can be said for the coast of Southern California in spring and early summer. Wherever you live or travel, you'll face seasonal characteristics of outdoor daylight. Much like the weather, you can talk about the light, but you can't control it.

If the light isn't right, should you take pictures anyway? If you don't foresee the opportunity again, yes. An exception is for some landscape subjects. Don't bother to shoot if the light is flat and the subject is featureless. Either return when the light is better or change the angle of the shot to capture the mood of the light. You may remember places where you took pictures under cloudy skies and regretted it, or you may have shot some pictures in the rain or on a dull day and were glad you did. Daylight and visual tastes vary. Making the right decisions concerning light and its effect will eventually give you more self-confidence with a camera.

AVAILABLE LIGHT PHOTOGRAPHY

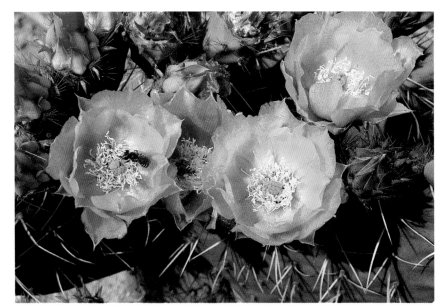

Closeup pictures outdoors are worth shooting in various angles of sunlight as long as the texture and form of the subject is clear. These cactus flowers were photographed in mid-afternoon on a spring day under hazy sun. With Kodachrome 200, I was able to shoot at 1/250 sec. at f/16. The lens was a 28-80mm zoom set at 80mm. Luckily the bee came along to add some interest.

On a visit to Idaho I wasn't very happy with the light as I passed through a ranching area, but I like the quiet pastel effect in the picture. The color areas are simple, the cattle well defined, and the overcast summer sky created a mood that turned out to be somewhat soft. When you are tempted not to shoot because you don't think the light is right, try a few pictures anyway. It could be a wise investment in film. This was taken on Kodachrome 64 with a 70-150mm zoom lens.

DAYLIGHT OUTDOORS

SUNSETS AND OTHER FAVORITE LIGHTS

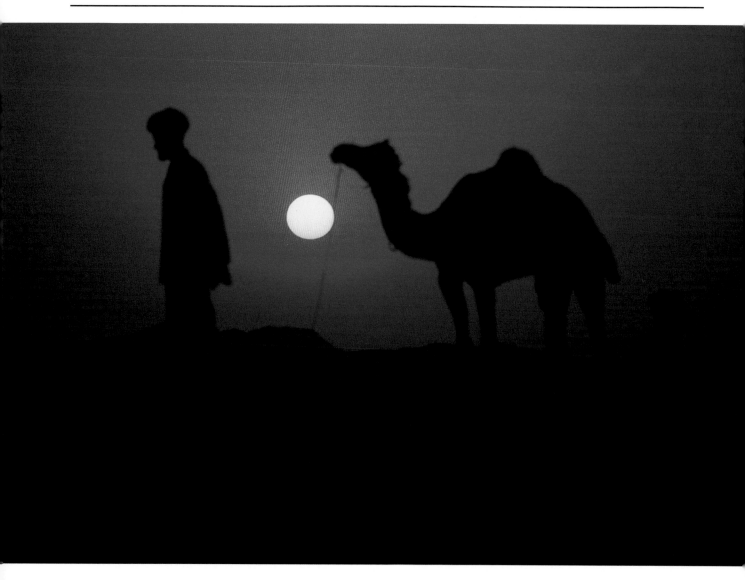

Lots of photographers gravitate to the kind of natural light that professionals like most: the pale rosy light of dawn that throws a pastel glow on mountains or city streets. Even more popular are the low golden rays of sun before it sets into the horizon. Backlight and sidelight are also favorites when the sun is behind the subject. For portraits, this light usually highlights the hair and sets the subject apart from the background.

Effective story-telling with a camera is often dependent on the direction and quality of the light. Visual quality springs from the color of the light; it is warmer at the beginning and end of the day and cool under a gray sky. Sunsets create marvelous pageants that almost every photographer has shot at least once. These spectacles change each

minute, so don't spare the film. Exposure by the meter's recommendation should assure good color saturation. Continue to follow the meter reading as the sun creeps below the horizon.

Nature's light is inconsistent, and you often have to make the most of the situations at hand. Strong, definite sunlight may dodge through clouds on a hot day—if you're lucky—and cast shadows from every natural and man-made form. Around noon in winter, take advantage of the sun slanting as it would in mid afternoon in summer. The importance of understanding how light changes is most evident when shooting at the wrong time. You tend to remember disappointing pictures and to learn from them to make the right moves and the right decisions with your camera.

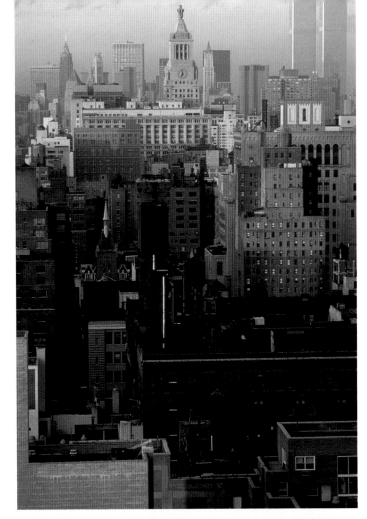

Tom Atwood shot the far left image in India with a 70-210mm lens on Kodachrome 200 film. "I could handhold the camera," he says, "because the shutter speed was 1/250 sec. at f/4.5, just what the meter indicated when the lens was pointed at the sun. I've always admired the image of a big round sun in a dark orange sky, but I know you need a 500mm or 1,000mm lens to get the sun really large." These lenses are usually bulky and thus require a tripod.

From the 21st floor of a building, Lewis Portnoy photographed Manhattan one day as the sun was rising. From his angle, he looked south to see parts of the city bathed in pale golden light and other parts in shadow. He used Kodachrome 64 with an 85mm lens and braced the camera against a window ledge.

Sunset is actually a type of light but is known better as a pictorial phenomenon that attracts every category of photographer. Bud Kennedy shot this on the Hawaiian island of Kona with an SLR, a 50mm lens, and Kodachrome 64.

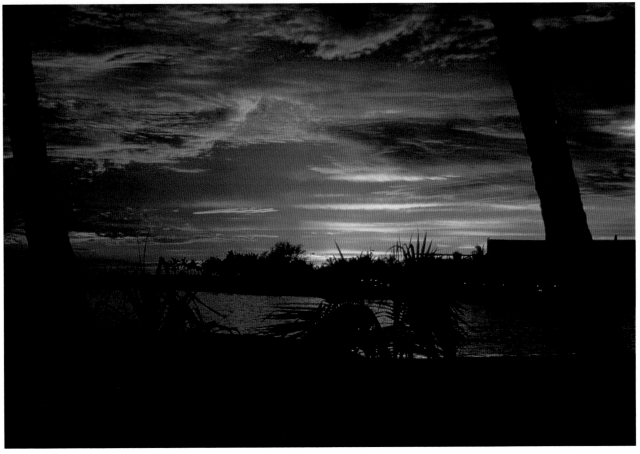

POSTER VISION

Jay Maisel studied painting before deciding to become a photographer, and much of his work reflects this. His work has been described as "painterly," applying primarily to his sense of strong and directional or soft and subtle lighting. His instinct for composition was probably influenced by studying with Joseph Hirsh who, Maisel explains, "was involved with formal considerations of color and light." Though he might have become an abstract expressionist painter, he chooses not to manipulate his photographic images, saying, "I only use filters if I'm obligated to use them for a client, or if I can't take the picture any other way."

Maisel waits patiently for the most dramatic light he can foresee. He looks for strong images that, like good posters, project their story immediately. His work is used in two-page advertisements, calendars, books on cities and countries, billboards, magazines, and annual reports. He often improvises on location as he shoots. Within Maisel's pictures the quality of the light is always intrinsic, and he exploits the power of color wherever he shoots. Among the outstanding qualities of Maisel's strong, memorable images is their simplicity. Extraneous subject matter is avoided, but beautiful light is always embraced.

"I make no apology for the pure joy of color for its own sake," he once said. "I speak out for the joy of yellows, the passion of red, the moods of blues."

Jay Maisel captured a moment in time where color, simple geometry, and human interest are the three reigning factors in the composition. While his images are simple, they retain a poster effect that can almost tell a whole story in a simple image.

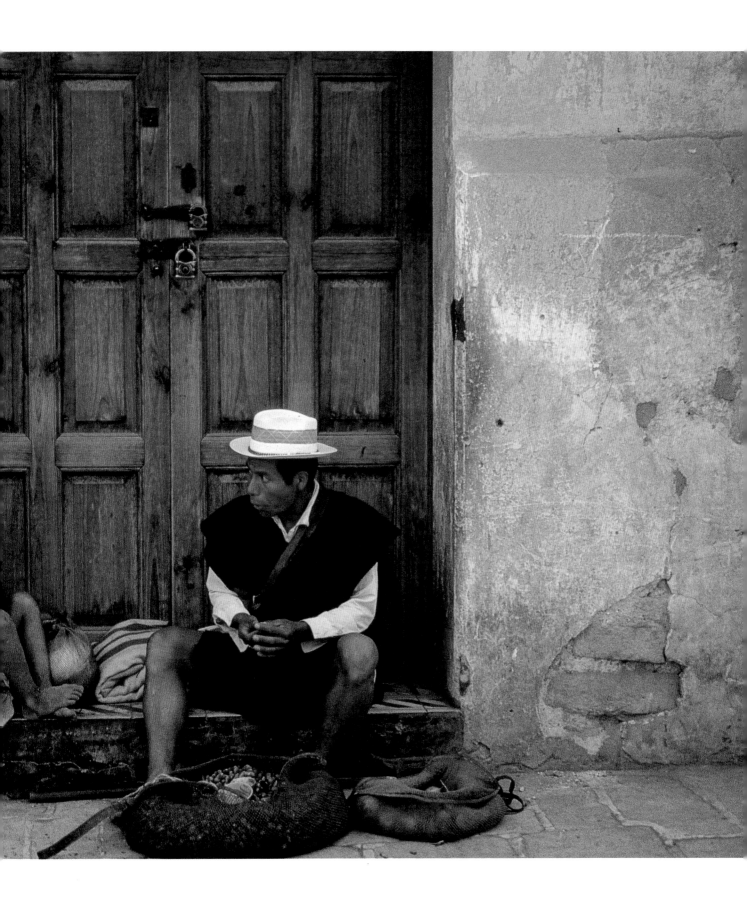

FROZEN COLOR

Eduardo Fuss is a veteran magazine photographer who became fascinated by patterns of leaves and debris in the frozen streams of New York state. When he moved to New Mexico he continued photographing similar patterns in a backyard pond. A painter as well as a photographer, Fuss seeks compositions and colors that make his artist's sensitivity glow. "I look beneath the surface," he says, "and I see worlds within worlds. Frozen air bubbles shine in the early morning sun. There are sun-and-shadow contrasts; bits of rock glisten." Fuss uses a 35mm SLR with either a 135mm lens and closeup extension tubes, a close-focusing 50mm lens, or a 105mm macro lens. With his camera on a tripod he aligns the lens almost perpendicular to the ice and focuses as close as the composition requires.

Fuss often shoots in winter sun to take advantage of the strong sidelight. "I avoid cloudy or overcast conditions," he says, "because clouds reflect on the ice surface, and even a polarizing filter doesn't help. So I wait for blue skies. Sunlight melts ice and weakens it, so I have to work fast sometimes. Early morning sun is best when it's still cold." Both thick and thin ice offer their own visual advantages and challenges, Fuss says, and the bright fallen leaves of autumn are easier to find in early winter.

The chilly winter light helps bring out pastels as well as dark colors and patterns of the leaves within the ice. Fuss' pictures, while simple in both execution and subject, are stunning examples of using color and pattern in composition.

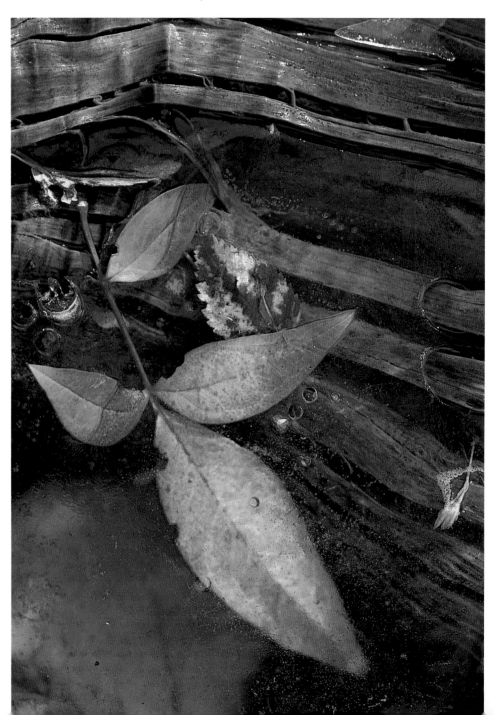

Compare the top photograph on the previous page with these two pictures, also taken by Eduardo Fuss. While bubbles in the ice eliminated some of the contrast, the hazy, indirect light of a cool winter morning gave that image its pastel glow. In the photograph above, however, direct light helped to highlight the colors of the leaves and the darkness of the ice they are embedded in. In the photograph on the right, sunlight brought out the contrast between the reflections within the ice .

AVAILABLE LIGHT PHOTOGRAPHY

VARIATION ON A THEME

Here is the same subject in three kinds of available daylight, which provides an opportunity to compare the characteristics of color and black and white as well as the impact of different qualities of light. Lewis Portnoy used a 35mm SLR and lenses ranging from 85mm to 200mm for his two shots, both of which were taken in Colorado. Like many successful pros, he is tremendously resourceful. On one shot he had to protect his camera from the falling snow until he was ready to shoot a series of motor-driven frames. For another he asked the horse owner to stand with him and whistle to bring the animals running. Then he exploited the rimlight from the side and back as the horses approached. Portnoy uses a motor drive in all kinds of light. Modern SLR cameras allow rapid shooting, from 1.5 to 3 frames per second using built-in winders and even faster with add-on motors.

Grant Heilman's black-and-white vision of horses was taken at noon, with the light coming from slightly behind the moving subjects. Heilman shot from a platform on the roof of his van with a medium-format camera and Tri-X film. With the shutter speed set at 1/500 sec., he could stop the silhouetted animals, while allowing their legs to blur slightly to emphasize movement. If you wonder whether there is a "right" light for photography, these variations of an equine theme indicate many ways to capture horses and other subjects on film.

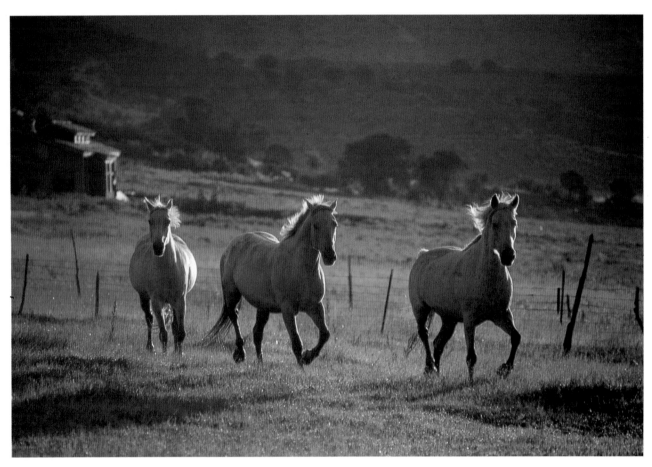

The sun was behind the horses and slightly to the right when Lewis Portnoy photographed this trio in Colorado. He used Kodachrome 64 in his SLR with a 200mm lens. To capture subjects coming toward the camera, using an autofocus camera is a real advantage; with a good lens, you can concentrate on composition and not worry about continually focusing.

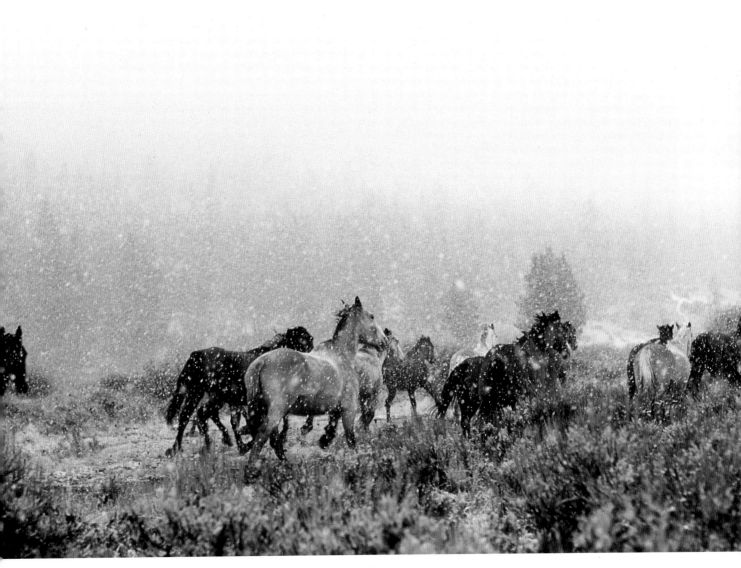

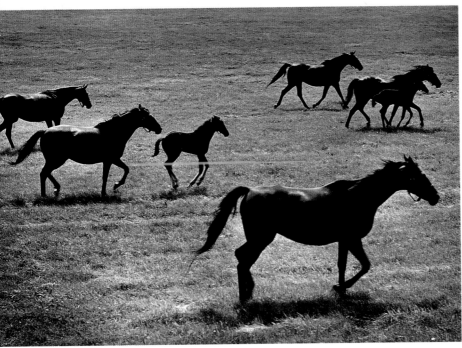

While shooting a story about ranch life in winter at the Triangle X Ranch in Wyoming, Lewis Portnoy shot from horseback through the pattern of a snow storm to capture a chilly pictorial effect. He used a 28-80mm zoom lens and Kodachrome 64 with a skylight filter.

Grant Heilman, an expert with scenic and agricultural subjects, photographed horses and colts crossing an open field in top light that provided beautiful contrast for the animals.

CHAPTER SIX
SHOOTING INDOORS

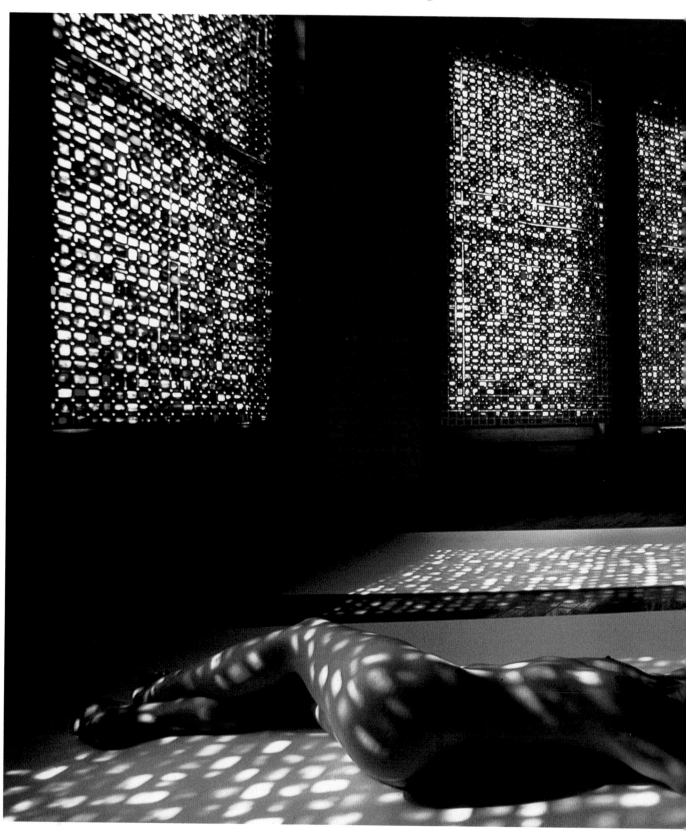

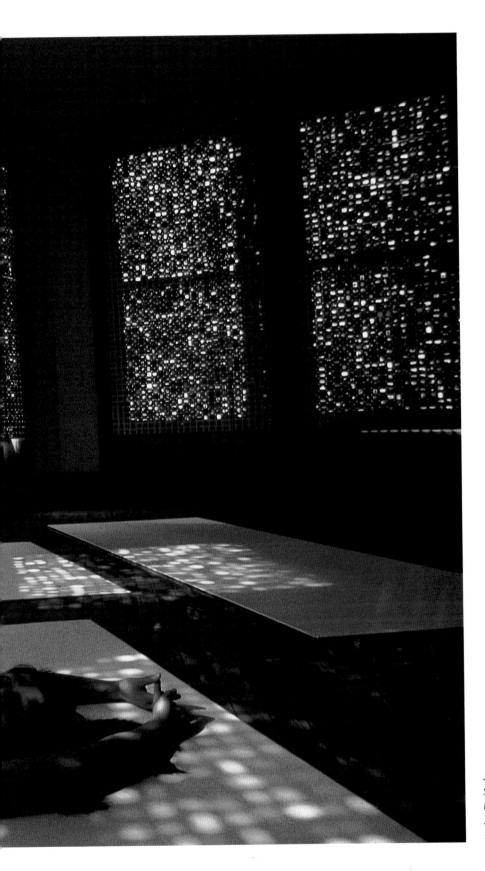

Jay Maisel photographed this remarkable room surrounded by stained-glass windows in Japan. The model struck many poses in the speckled light and Jay eventually decided to show the whole area in the image by using a wide-angle lens.

INSTEAD OF FLASH

The urge to take pictures with flash indoors is inevitable; almost all photographers do it, including me. And in everyday life, these situations are everywhere. Relatives are visiting and you want quick pictures of them with your family. Neighbors come by in their Halloween costumes and you grab the camera with the flash attached to snap a few shots. You attend a child's indoor birthday party in a dimly lit home where you almost have to use a flash. Electronic flash is the expedient way to photograph people and events indoors. You can freeze those happy smiles and catch spontaneous action easily because flash is fast and easy, and people are used to it.

But it may have occurred to you that almost all pictures taken with flash on the camera tend to have the same look. Small black shadows are attached to everyone and everything you photograph. Backgrounds are often dark and anonymous because there is not enough light from the flash to cover everything. Light from the average small flash is good for about 10 or 15 feet, depending on the speed of your film. You can bounce the flash against a ceiling or reflector for wider illumination, but it takes more effort with an SLR, and not all ceilings are bright enough.

In contrast, indoor ambient light often has qualities that make pictures more interesting and usually adds to the mood or substance of the subject. When you shoot in mixed light—several types of artificial light mixed with daylight coming through windows—color may tend to be more toward the warm or cool side, which can be visually appealing. Color mixtures from tungsten and fluorescent sources plus daylight are usually more attractive and preferable to flash, and the shadow-attached flash look can be avoided. For black-and-white films, the same things can be said about the more natural qualities of indoor ambient lighting. Healthy contrast and pearly tones of gray help give your pictures more character and realism, while manipulation in the printing process gives you added control over the outcome of the image. The realistic look of existing light in many indoor locations can help you to create pictures with individuality and impact.

AVAILABLE LIGHT PHOTOGRAPHY

These sculptures of sacred figures from India were spotlit at the Norton Simon Museum in Pasadena, California. With Kodachrome 200 in my SLR I was able to handhold the camera for a 1/30 sec. exposure. I underexposed 1/3 stop to avoid an averaged exposure that would have made the black background lighter. Normal exposure would be preferable with color negative film. This approach helps because most museums prohibit the use of flash.

Professional photographer Terry Pagos of Seattle undertook a challenging personal project to document men at work in their own environments. This father and son have their own machine works. Said Terry, "As a photographer who spends most of my time shooting large format pictures of products and people in my studio, it was fascinating to work with existing light; in this case, a mixture of daylight and fluorescent light." Terry used a 55mm lens on her SLR with T-Max 3200 film that was developed in HC 110.

MIXING LIGHT SOURCES

Many of my indoor shots of family and friends during the 1980s are color shots taken with flash. In earlier years, I often used existing light for both black and white and color, but flash became easier to use in the last decade as dependable automation was developed. Having taken thousands of indoor pictures for magazine stories in available light in the past, I guess I became less interested in lighting realism for my personal archives; flash pictures just became easier to take. Another reason for more flash shots is that in recent years I've often used a point-and-shoot camera for print film shots of my family and friends. With these cameras, the built-in flash is so easy to use that sometimes it becomes an unconscious decision. However, when I shoot negative color film with an SLR, I seldom use flash with faster films.

Most of the indoor pictures that I took during the past decade were shot on color slides using existing light, and handheld when possible. The main reason for not using flash is that usually these pictures are taken for stock sales, and I try to make the images more realistic. I generally prefer softer lighting without any harsh shadows. If I do need to fill in shadows, and want to avoid using any flash at all, I'll use a piece of 20 x 30 inch illustration board as a reflector.

When you shoot pictures indoors, the quality of the existing light is often the element that will inspire you to shoot without flash. One type of common indoor light is relatively bright, indirect light reflected from outdoors then bounced from the walls indoors and mixed with existing room light. Such light may be diffused and spread widely; but when more localized, it can be strongly directional. If shadows aren't too dark, this kind of diffused lighting can be beautiful. The other type of indoor light is more direct, usually from overhead fixtures, lamps, or rays of incoming sunlight. This is likely to create darker shadows, although overhead fluorescent lights often distribute the light more evenly, thus cutting back

Because prints made from color negative film are more easily manipulated, it would probably have been a better choice than Kodachrome 64 in my SLR at the Guggenheim Museum in New York City. Here you can see the green tint of fluorescent lighting in all its glory. I usually carry a Tiffin FL-D filter to correct this condition, but I forgot to use it here.

AVAILABLE LIGHT PHOTOGRAPHY

In the past, professional photographers hung huge electronic flash units in sports arenas and set them off by remote control. With the advent of the fast films, Lewis Portnoy was able to shoot the L.A. Lakers against the (then) Kansas City Kings with Fuji 1600 print film. Lew shot at f/2.8 and 1/500 sec. and later had slides made from the color negatives.

SHOOTING INDOORS

In this image, I chose Kodachrome 64 film and added quartz lights to the overhead fluorescents and the minimal window light. I also used a Tiffin FL-D filter to counteract the potential fluorescent-green tint. Fluorescent is almost always the "wrong" light, but it can be controlled. Another way to tackle such a mixed light situation is to use a color negative film. Prints are usually automatically color corrected, and slides can be made from negatives.

AVAILABLE LIGHT PHOTOGRAPHY

on the shadows. A good tip is to look at people's eyes. If the eye sockets are too dark from the shadows, try to find a better angle or location. Reflected light can be of great help to fill in any unwanted shadows for portraits.

Even when the light is bright enough to shoot handheld comfortably, some photographers may feel an urge to fill the shadows with flash. Modern cameras do such a good job of automatic flash-fill that in most circumstances the ambient light is not overpowered, and the feeling of the natural scene is left intact. I use flash-fill for a lot of snapshot-type pictures in harsh directional light indoors. But when the light is good and gives the subject the character or authenticity I'm looking for, I rely on available light alone. Try it for yourself. Shoot flash-fill as well as existing light pictures of the same situation, and compare the results. This may teach you to see what you will need for each lighting situation and could help you react more instinctively later.

The lighting conditions described above apply to black and white as well as to color. For black and white though, mixing light sources is not as much of a concern because the different light sources will have the same effect. Fast black-and-white films also have relatively less grain than fast color films, and contrast can be controlled during printing. You can reduce contrast by slight overexposure and slight underdevelopment. To increase contrast, just reverse these controls. For instance, on an overcast day you can boost the contrast by underexposing one-half stop or more and overdeveloping the film by about 10 to 20 percent. While this method helps, varying the contrast grade of the paper is a more precise way to control contrast. Printing papers come in grades from 1 to 5, with the number 2 grade considered normal. Negatives with a lot of contrast can be balanced out by using the number 1 or number 2 papers, while a negative that is underexposed or flatly lit will appear stronger on the number 3 or 4.

There is a category of photographers who pride themselves on their ability to avoid electronic flash when shooting in indoor available light. They take pictures in homes, offices, gymnasiums, and elsewhere with all kinds of existing artificial light and incoming daylight. For such austere people there is no right or wrong light because they make do with what is on hand. They may use correction filters with slide film or let the printer make adjustments with negative color film. I've never been that rigid about lighting. I prefer to use existing light if I'm working on a magazine job, but I'll add floodlight or flash when necessary. Today, many media photographers light their subjects with powerful portable electronic flash units and large umbrella reflectors. Most photo illustrations in magazines are smoothly lit with a variety of studio flash units.

A few years ago I photographed a furniture craftsman in his shop (left) where the combination of fluorescent lights overhead and daylight coming through windows was not bright enough for the Kodachrome 64 I was using. I added quartz lights and shot from a tripod at 1/8 and 1/15 sec. with a Tiffen FL-D filter. I found that the quartz lights, too warm for the daylight film by themselves, helped neutralize the greenish tint of the fluorescent lights. Fluorescent tubes, in cool or warm tints, produce excess green and blue light and require the special Tiffen FL-D filter for daylight-balanced slide film. Try experimenting with these as well as a #30 magenta filter.

With slide film, you take a chance shooting in a light source different from the one for which the film is balanced. For color negative film, you have less to worry about, and for black-and-white, the effect is minimal. Theoretically, there are right and wrong light sources for color films, and careful photographers use a color temperature meter to know which color correction filters are needed. Like most readers, I haven't needed to be that precise. Shooting for publication, though, I do use correction filters with daylight films and tungsten film indoors. There are also indoor situations where handheld flash isn't appropriate—for example, at basketball games in sports arenas or inside museums where flash is usually prohibited. Many of these places are bright enough to shoot handheld with films in the ISO 200 to 400 range. In cases where you can't use a tripod, take along some faster film in the ISO 1000 to 1600 range. For comparison, if the exposure is 1/60 sec. at $f/2.8$ with an ISO 100 film, it will be 1/60 sec. at $f/5.6$ with an ISO 400 film, and 1/125 sec. at $f/6.3$ with an ISO 1000 film.

When tungsten room light is really weak, its color temperature is lower than floodlights. Subjects will appear very warm on daylight film and a little less so on film designated at 3200K or 3400K and balanced for tungsten or quartz-halogen light. Weak indoor light or light sources found in places like a sports arena can be handled effectively with negative color film and color-corrected during printing. In weak artificial light, shoot without flash if color quality is important.

LOW-LIGHT SITUATIONS

When the light level indoors is at about 1/15 sec. at *f*/3.5 and I don't have a tripod, I brace the camera against walls, pillars, or whatever is handy, hoping for reasonable sharpness. Sometimes I've been lucky, but more often than not some camera movement spoils the pictures. (I'm not showing blurred pictures here, especially those I tried to shoot at 1/8 sec. or slower, because we all have some examples of these.) Since slow films are a handicap in many ambient light situations, I use the faster Kodachrome 200 more often. I've also switched to using Ektachrome 400 or the ISO 400 and 1000 speed print films and having slides made from the best negatives. The vivid color and fine grain of Kodachrome, Ektachrome, or Fujichrome, even at the higher film speeds, are satisfying for most purposes. In order to use slower slide films indoors, I use a tripod as often as possible. Sometimes though,

a moving subject that is blurred slightly can be quite nice in the right context.

The more you shoot indoors in places such as museums, gyms, living rooms, or classrooms, the more you can appreciate the qualities of good light where you find it. If you can brace the camera or shoot from a tripod, low light levels can give you great results. In slides I try to expose for good highlights and let the shadows fall where they may, while the reverse is true for color negative film; it generally needs 1/3 to 1/2 stop overexposure.

Remember that you can augment contrasty light by bouncing flash against a reflecting ceiling or wall for soft fill. When shooting indoors, it also helps to be conscious of depth of field. Realize that when the light level is low, you can't handhold a camera and stop the lens down to get an adequate depth of field. Instead, try to brace the camera or use a tripod and

A dining room in the Netherlands had a certain ambiance due to the early-morning light. When I travel, I usually keep a camera with me because pictures happen in the most unexpected places. I was using an SLR with a 35-70mm lens that is about the size of a 50mm F1.5 lens. Modern zoom lenses are wonderfully compact and sharp.

choose a slower shutter speed for better sharpness in both the foreground and background. When you switch to a 21mm, 28mm, or 35mm lens, you can still shoot at wider apertures and get overall sharpness at slower hand-holdable shutter speeds.

When there are colored lights or bright spotlights in the scene, keep in mind the color and contrast of the scene, but first of all, compose for the image. With certain lights, you can get a theatrical effect that professional photographers often try to create with artificial light. Available light pictures indoors are often more interesting because they look real, but dramatic or color-distorted fantasy effects are also welcome.

It is remarkable how often the quality of the light fits the scenes and subjects found indoors. Examine some of your pictures. Which ones are good because you fortunately found the light so soft or directional that it helped the mood of the subject? Do you have pictures of people whose actions look more spontaneous because the light was even and bright enough to shoot quickly? Were you luckily using an ISO 400 or 1000 film just when something unexpected happened, so you could catch it? If you've enjoyed such experiences, you know the satisfaction of not using flash. Existing light can make the photographic narrative more appealing and perhaps more original.

An elegant drawing room in Chirk Castle in Wales was handsomely lit by a row of windows along one side. I used a 28mm lens here, though a 24mm or 21mm would also have been okay. No tripods were allowed in the castle, so I braced the camera with Kodachrome 64 in it and shot at 1/15 sec.

PORTRAITURE

When you arrive somewhere, like a friend's home, a museum, or a sports arena, and you decide not to use an electronic flash for your pictures, accept the light that is available and work with it. If daylight is coming through the windows and there is enough artificial light indoors, you could be in luck. The light might be in bright or dark pools and could be useless, but if you're taking portraits you have some latitude: You can move people into the best light and settings. You can open or close doors and windows, and turn lamps on or off. A combination of some soft or directional light, a pleasant setting, a simple background, and a willing subject are the perfect ingredients for appealing indoor portraits.

Make sure the background in the portrait is not too cluttered. If it is, shoot it out of focus. Portrait light is best when it is "even"—direct or nicely indirect—as long as the contrast between highlights and shadows suits the subject. When you have enough time, look for a spot with dominant reflected light, the kind that studio photographers make with big umbrella reflectors or diffusion screens. When there is strong light coming through a window, try using it on one side of the subject and place a reflector on the other side to brighten the shadow area. Or place the subject's back to the window and reflect some light to fill in the darker areas. Whenever possible, shoot portraits from a tripod, and use a lens that is 80mm or longer for a more flattering look. Pictures will be sharper too, especially when you need to use slower shutter speeds. Don't economize on film whenever your pictures could be significant, especially when you're shooting portraits. You'll get quality from quantity when you shoot purposefully.

Because the light in most interiors is either fluorescent or tungsten, pictures may come out tinted green or red. Daylight coming through a

This is what I call "one-sided" light, which can make an everyday subject pictorially dramatic. Visiting a friend, I noticed how the light from the window illuminated a dining-room sideboard, and decided that it would make a good portrait setting. I wanted to keep the background in focus, so I used the smallest aperture possible for adequate depth of field.

A member of a rowing crew stopped momentarily as he left a boat dock to pose for Jay Maisel. The sidelighting in this photograph is reminiscent of the style of the Dutch painters. According to Maisel, "exposure to many arts forms an attitude and helps one to appreciate all contributions to visual design on many levels—color, form, line, and light."

window or glass door usually improves the color balance. Conditions are good when the window faces north or isn't full of direct sun while you're shooting. The sky acts as a great reflector and diffuser, and indoor light is often beautiful for portraits. The softer the illumination, the more flattering it is to the subject. Shadowless reflected light, from the sky or from your own reflector, is usually ideal. Have the subject sit or stand near the window, and turn him or her around slowly to determine which direction is best. If the light is fairly uniform, take your exposure reading from the camera position and let the meter average light and dark. If the subject is edge-lit, and the dark area predominates in the shot, take a reading from the person's face and expect the background to be slightly overexposed.

Environmental portraits include some of a person's surroundings that reflect his or her personality. In addition to closeup shots, try some distant shots to show the living room, office, back yard, or whatever. And let people pose naturally. Using available light leads to more informal portraits, and people should be relaxed. They may find your realistic pictures more satisfying than the more posed, slickly lighted images they get from a studio. Certainly they will be happy to see themselves without the effects of flash.

James Cook photographed famed portrait photographer Arnold Newman in Newman's studio with only window light and the overhead fluorescent lights. According to Jim, the image was made with an "autofocus SLR with a F1.4 50mm lens and Kodak T-Max 400 film. I used the Maxxum 9000's built-in spot meter to read selected areas and shot at 1/30 sec. at f/5.6 handheld."

As you can see from the graininess of the image, Bob Clemens used T-Max 3200 film for this photo. The dancers are posing momentarily for Clemens by a large window in front of a plain background. Off right was a reflector or another window farther away that brightened the shadows.

AVAILABLE LIGHT PHOTOGRAPHY

Jim Cook photographed Ruth Black Bear, of Wounded Knee, South Dakota, sewing a patchwork quilt in her bedroom. Jim used Ektachrome 200 in a handheld SLR and an autofocus 35-80mm zoom lens. Jim was able to shoot at 1/30 sec. in a setting where flash would have been intrusive.

CHAPTER SEVEN
AVAILABLE DARKNESS

For their book on Vanderbilt, Will and Deni McIntyre spent weeks photographing the university campus. These tents were being readied for an alumni gathering. According to Will, the people were just beginning to arrive, the sun was down, and clouds filled the sky. They used Kodachrome 64 and an 80D filter (mid-range blue) to correct some of the warmth of the tungsten lights. They spotmetered the scene and shot at 1/2 sec. for dramatic color saturation.

THE DIFFICULT LIGHT

As I was waiting for a wedding ceremony to begin, I noticed how the late-afternoon light fell on the man in front of me. The exposure reading through a 50mm lens on my SLR was 1/8 sec. at f/2 on Kodachrome 200 film; but I shot this at 1/15 sec. because I wanted a darker background for the edgelighting. I consider it lucky that I held the camera steady at less than 1/30 sec. and and still got a sharp image.

In the 1950s somebody coined the term "available darkness" to define existing light that was dim and difficult to shoot in. At that time, fast color films hadn't been developed, and black-and-white film was only as fast as ISO 100. It wasn't until 1954 that Kodak came out with the Tri-X film rated at ISO 400. Until then, it was a challenge to shoot in poor light. Grain was a kind of merit badge in published photographs. If a photographer was motivated to shoot an unposed, realistic image in available darkness, he or she was to be commended, no matter how large the resulting grain. That mystique has faded and today there are several levels of available darkness. On the brighter level there is enough light to take pictures with a handheld camera, though you may have to shoot at 1/30 sec. or even slower. On the darkest level, the light can be so dim that you have to brace the camera or a use a tripod while shooting slower than 1/30 sec. at f/2 or f/1.5, usually with a fast film. And if you're trying to capture moving subjects, you'll be lucky to get images with marginally acceptable sharpness; you probably should have switched to flash or used a tripod in the first place.

There is a dividing line between available darkness and shooting at night. In this book, photographing in difficult light means using a handheld camera and bracing the camera against something or working from a tripod, usually at exposures of 1/2 sec. and faster. In some night situations you can easily shoot handheld exposures because buildings or people are brightly lit (Las Vegas or New York's Times Square for example), and the darkness is relative. Real night photography means using a tripod and making exposures of 1 second or longer.

Photographers in the 1990s are fortunate because modern fast films and improved emulsions are available. Imagine having to shoot outdoors in 1910 when Lewis Hine took the picture "Tenement Dweller Carrying in Country Coal, Chicago." Hine was a brilliant, modest, and adventurous photographer who also documented construction of the Empire State Building in the early 1930s using a handheld 4 x 5 camera hundreds of feet up on steel girders. Hine captured real-life situations with a view camera on a tripod.

His fastest lens was perhaps F6.3 or F8 and his film might have been rated ISO 3 or 5. Notice that in Hine's picture there is little depth of field because he probably shot with the lens almost wide open at 1/50 sec. on a cloudy day.

Today, photographers are still trying to capture the unexpected in everyday life; however, in 1991, working in the available darkness is a lot easier and results can be more satisfying. If you choose to avoid using flash, adapt your skills to include today's fast films and the wide selection of lenses available. Grain may be increased, but you can take exciting and interesting pictures of reality without the frustrations of earlier photographers.

This photograph, taken in 1910 by Lewis Hine, is an example of how painstaking photojournalism was in the early 20th century. While the light in the image is quite low, there were no fast emulsion films or quick lenses in those days. Hine also shot available light pictures in factories, and his work was helpful in getting child labor laws passed. (Courtesy of George Eastman House Collection)

AVAILABLE LIGHT PHOTOGRAPHY

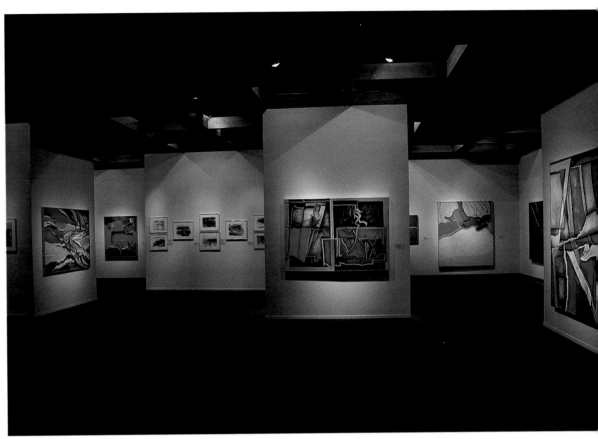

When painter Rita Deanin Abbey had a 35 year retrospective of her work at the Palm Springs Desert Museum, I took some informal slides for her. My SLR was handheld with a 28mm lens at 1/30 sec. using Kodachrome 200 film. Artificial light gives a warm look to interiors photographed on daylight slide film, but the vivid colors of Rita's paintings are accurate. I might have gotten permission to use a tripod, but I preferred to handhold the camera because it was more expedient in that light level.

A 1/4 sec. exposure at the water and light show on the left qualifies as available darkness rather than night photography because the camera was handheld. The meter reading was actually a 1 second because of the dark background and dark red lights, but my Kodachrome 64 slide would been washed out at that slow speed. I tried a 1/4 sec. and 1/2 sec. but preferred the color saturation on the faster exposure.

CAMERA BRACING TECHNIQUES

Before you even look through the camera viewfinder, you should instinctively get an impression about the character of the light wherever you are. After you see the exposure reading and compose the picture, you may have to decide if a steady handheld exposure is feasible. Will there be enough depth of field, and how much movement can you expect from the subject? Will pictures shot at a slow shutter speed be sharp enough if you hold your breath and squeeze the shutter release gently? If you're lucky, pictures are suitably sharp, but when sharpness is just not possible to achieve with a handheld camera, you should mount your camera on a tripod to avoid any camera shake whether there is subject movement or not.

Choosing a tripod is a matter of compromise. I'd like to have a model that opens to 5+ feet, telescopes down to 12 inches, tucks into a gadget bag or hangs neatly from a belt, and is sturdy enough for a 2-pound SLR camera. Sorry, no existing tripod fits my compact, light-weight description. The smallest and lightest models are not tall enough to bring the camera up to eye level at full height. There are miniature folding tripods that are only 8 inches long and weigh 1/2 pound, but they only elevate an SLR about 10 inches. This is fine on a table, but a tripod's primary use is to expedite field work. You can brace a camera on this tiny tripod against a wall, but that is often a clumsy way to shoot.

I must admit that I don't carry a tripod often enough. I've learned, as perhaps you have, to brace an SLR or point-and-shoot camera against poles, fences, steps, chairs, railings, walls, windows, and other handy stationery objects. When the edge or bottom of the camera can be held squarely against something, you can sometimes shoot between 1/15 sec. and 1/4 sec. without camera movement. Sometimes though, when the camera is braced, even when you hold your breath, you can count on some invisible force to shake the camera. It doesn't take much movement to cause pictures that are unsharp. Time and again I've thought that I've braced the camera successfully, only to end up with pictures that look as if they were taken in a mini-earthquake. Lights at night may look decorative when blurred, but most subjects are unrecognizable, and the pictures are embarrassing.

Practice bracing your camera, and learn to shoot successfully at slow shutter speeds in available darkness. You may have to adjust the composition slightly depending on the location of a steady camera brace, but that is often a useful compromise. Try placing both elbows firmly on a table, for example, with your chest or stomach against the table, making kind of a human tripod. Just relax, and avoid any tension because this can cause some shaking too. Sharper pictures are more feasible when you brace your camera, shoot with a large aperture such as *f*/2, and use a film that is ISO 400 or faster.

Tom Atwood arrived at a Lamaist temple in Lhasa, Tibet, with Kodachrome 200 in his SLR. Flash was prohibited, so the faster film, while a little more grainy than Kodachrome 64, was suitable enough for the low light. Some shots were handheld at the lower shutter speeds, but most were braced against a pole or wall.

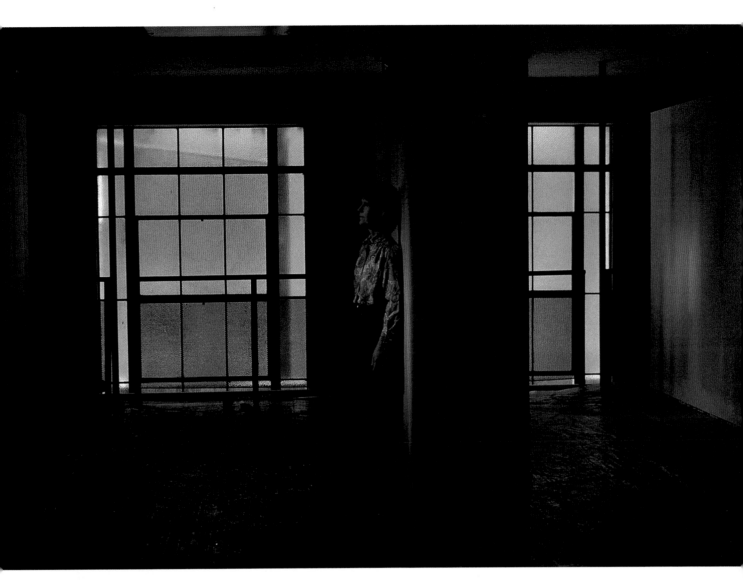

It is hard to find low-light situations where there is good contrast in the picture. The windows in this room under construction were bright, but the walls, the floor, and my model were in shadow. Without a tripod handy, I braced the camera against a wall and shot at 1/15 and 1/30 sec. I ignored the meter reading that indicated a higher shutter speed because of the bright windows. There was more detail in my picture at 1/15 sec. but I preferred this exposure at 1/30 sec. because it has good detail from the window as well as a little mystery.

AVAILABLE DARKNESS

HIGH-SPEED FILM

Fast color negative and slide films are extremely versatile these days; you can see various examples of how they perform throughout this chapter and the next. You may shoot either black-and-white or color films in available darkness at either their designated speeds or at higher speeds suggested by the manufacturer. This is called "pushing" the film, which means that it can be exposed at an ISO speed higher than the one designated and development time is increased. For instance, Kodak T-Max 3200 and Fuji Neopan 1600 can be exposed at several ISO speeds depending on development time. T-Max works well at ISO 6400, and the Fuji 1600 film may be exposed at ISO 3200 and push-processed for additional speed. Kodak T-Max 400, Tri-X (ISO 400), Fuji Neopan 400, and Ilford HP5 can all be pushed to ISO 800 or faster. Each film manufacturer offers data on pushing and recommends developers and developing times with which you can experiment. I've often boosted Kodak Tri-X to ISO 1000 using Accufine developer, and the results have been quite acceptable.

You don't need your own darkroom to be a creative photographer. Custom processing labs for black-and-white and color can boost film speeds and achieve special effects. Ektachrome P800/1600

Professional film may be used at either speed and then push-processed. Other Ektachrome, Fuji, and even Kodachrome films can be pushed, but you should check with a custom lab for specific details. Remember though, when you push any film, grain increases and contrast in color prints may diminish. Reserve pushing a film for minimal light situations in which you want either to retain a sense of realism or to avoid disturbing someone.

The new fast color slide and print films could also be an adventure and may help improve your style. Grain is noticeable in all faster films when they are enlarged, and grain size does affect sharpness. But grain structure and chemistry have been noticeably improved in the past several years. Face it, if you want to shoot in available darkness without flash, grain is inevitable; but remember, color does offer its own rewards. Mass production color-negative processing labs, with their advanced automation, do very well today. This can be an encouragement to find opportunities to shoot in relatively dark places where everyone expects you to use flash and can't figure out why you don't. Your picture could have a sense of place in available light that may be lost in a fraction of a second with flash. Hopefully, the images will be praised for their realistic mood, emotion, and action.

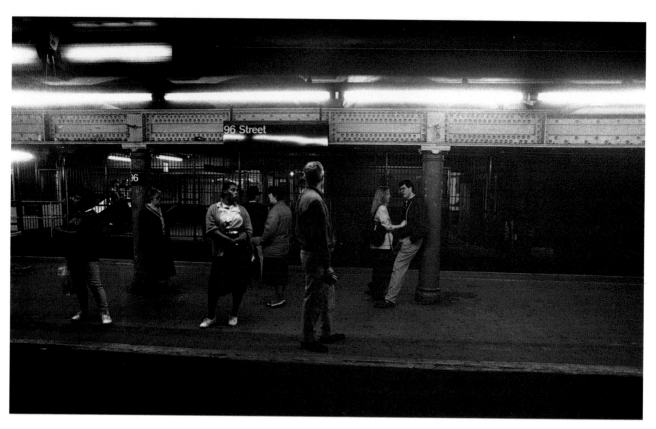

About 80 years after Lewis Hine photographed on a street in Chicago, James Cook rode a subway beneath the Manhattan streets testing Kodak T-Max 3200 film with an autofocus SLR. He used an F1.5 50mm lens and exposed the image on the left for 1/60 sec. at f/2.8. According to Jim, he was really more interested in experimenting with the film than the actual picture content. However, Jim's candid view of the 96th Street station is in the best tradition of street shooters past and present.

More than 20 years ago I photographed Zubin Mehta, the world famous conductor, for a magazine assignment with Kodak ISO 400 Tri-X film. This is still a favorite of photojournalists and others who value a fast film with relatively fine grain. I had my SLR on a tripod with a 300mm lens and probably exposed at 1/60 sec. at f/8 with the stage lighting. I was given only a few minutes to shoot from the wings during a performance of the Los Angeles Philharmonic Symphony. I rated the film at ISO 1000 and push-processed it in Accufine.

TESTING YOURSELF

I hope you are already using your cameras in low light levels and are enjoying a personal sense of pioneering. I've often speculated that serious amateur photographers may get more pleasure from taking pictures than professionals do because amateurs only have to please themselves. Professionals have deadlines and the stress of competition to deal with, and they may become dulled by shooting some subjects repeatedly. Serious amateurs can choose their own subjects, experiment with new techniques, and take chances with no risk of losing their jobs or reputations. Their main satisfaction and motivation result from their continuous creative development and the admiration and encouragement from those who see their images.

The rewards can be even greater for those who consistently carry a camera because practice and risk-taking in all kinds of light are the necessities of learning. An amateur can experiment by shooting in weak light without flash, and, if the pictures fail, experience only a temporary disappointment. A professional has to use flash or other lighting when it is needed because he or she can't go home without the pictures. Also, don't be too discouraged with pictures that are blurred, underexposed, badly lit, or otherwise flawed. You'll learn more from your mistakes than from your best images. If you try to shoot handheld photographs in miserable lighting and get shaky images, those pictures will stick in your mind and you'll probably do better the next time.

One insurance against failure is to shoot plenty of film; it is certainly cheaper than an airline ticket or the mileage you pay to drive somewhere. You can get quality from quantity, and the more you shoot with distinct ideas in mind and with a purpose for each exposure, the better your chances of photographic success. That applies especially to shooting in low light levels where camera or subject movement and contrast problems can ruin pictures. A few good shots on a full roll are your reward for patience and perseverance. Carry your camera and use it often. Modern exposure systems, films, and lenses are all your allies. Enjoy the freedom of being your own boss in available darkness.

It rained so hard on an English country road that I pulled the car over and waited for the storm to break. It was difficult to focus through the wet windshield because nothing in the scene was sharp. I didn't remember to use a skylight filter, which is just as well because colder light fits the situation. This kind of natural "special effect" is one that non-professionals can take for the fun of it.

Opportunities for self-portraits are frequent and can even include reflections from hubcaps, mirrors, or shop windows. Indoor reflections may be in low light levels such as this one at a museum in Pasadena, California, where I pressed myself against a wall and shot at 1/8 sec. on Kodachrome 64. The other ghostly person is my wife. By using a faster film you'll avoid possible camera shake in situations like this.

At a late afternoon wedding the bridesmaids were attentively watching the ceremony. Characteristics of the light were what made the picture. The young ladies were edgelit against a varying background, and above them were tungsten lights that gave them all a warm glow. I shot with Kodachrome 200 in an SLR at 1/30 sec. almost wide open at f/4.5 with a 28-80mm zoom lens. A little flash fill would enhance the picture, but the authentic look may have been compromised.

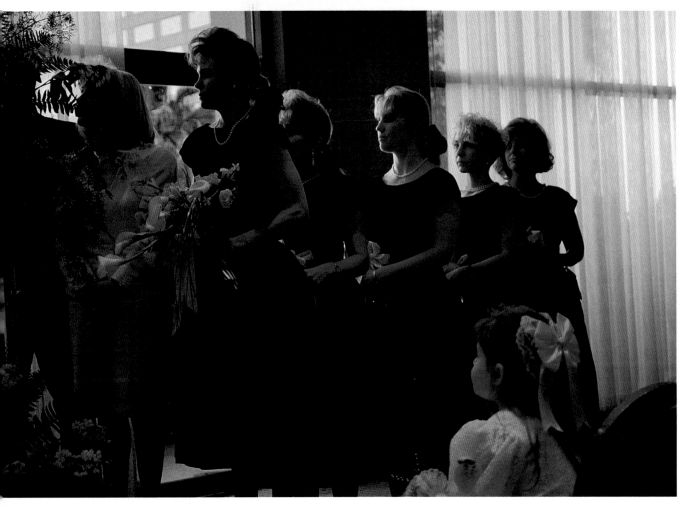

NIGHT PHOTOGRAPHY

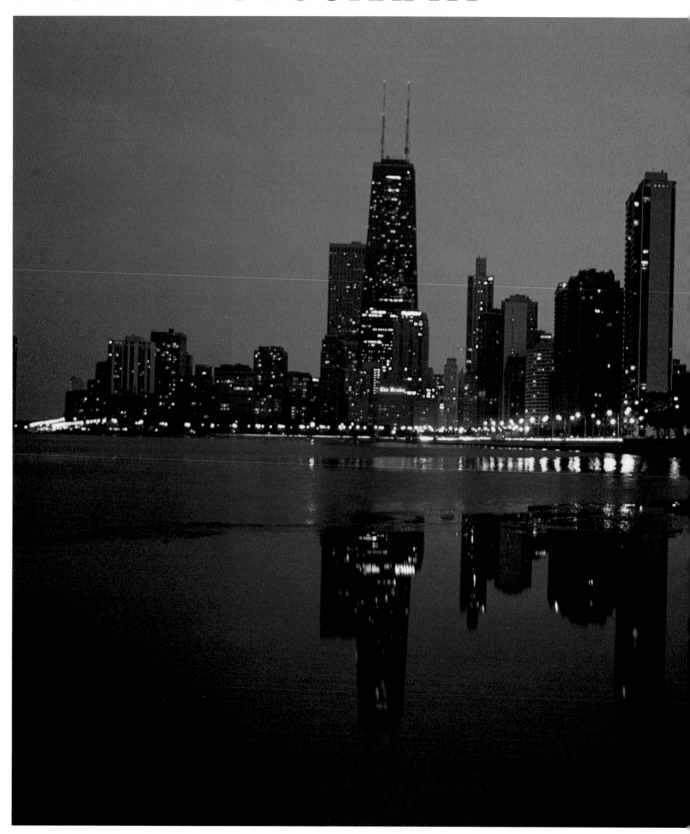

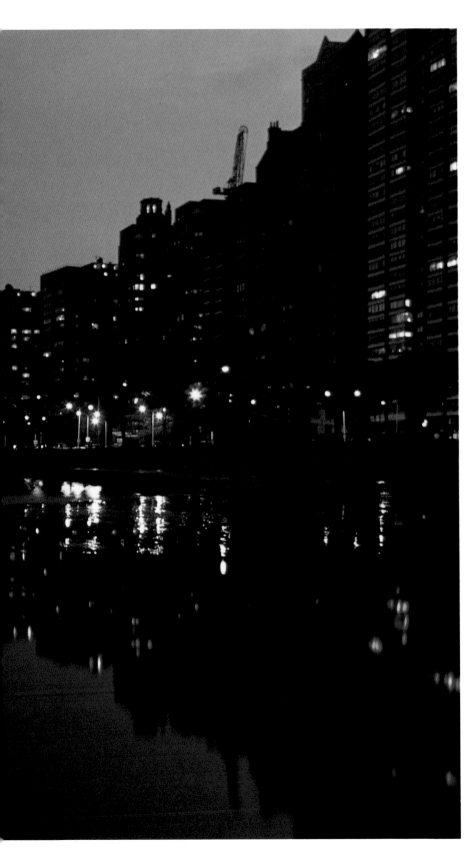

With simple timing, photographers can mix a twilight sky with a night view of a skyline or other subject. Lewis Portnoy put his SLR on a tripod, and at just the right moment made this exposure of Chicago's lakefront and the lights of the city. He used Kodachrome 64 and exposed for 2 seconds at f/8.

NIGHT PHOTOGRAPHY

FILM COLLECTS LIGHT

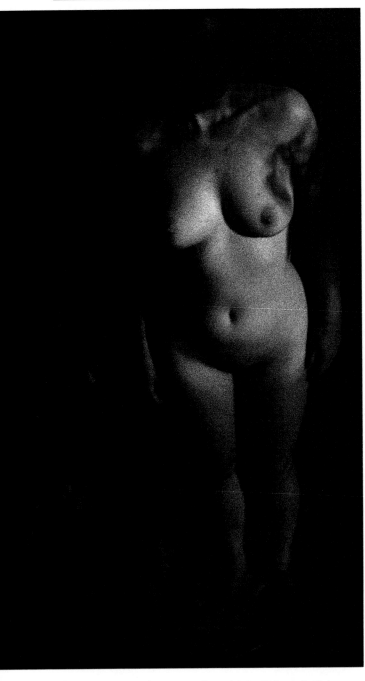

After shooting some indoor pictures of a model, Derald Martin decided to see what Kodak T-Max 3200 film in his SLR would do in moonlight. "I put the camera on a tall tripod," he explains, "and shot with a 50mm lens wide open at f/1.4 for 1 sec. I couldn't see the meter needle very well in the dark so I guessed at 1 sec. because the model said she could hold still that long." The exposure he used is equivalent to 128 seconds at f/5.6 with an ISO 400 film, or six minutes with an ISO 100 film. He intentionally placed the model's face in shadow to add to the incongruity and mystery, and his moonlight experiment was successful.

Maybe you recall the first night pictures you ever shot and the dramatic impression they made. Mine were of two people on a snowy street. Using black-and-white film in a 6 x 6cm twin-lens-reflex on a borrowed tripod, I shot a couple of true friends standing in the cold, lit only by a streetlight. Because I had no experience and was using a primitive meter, I exposed at around 1 or 2 seconds. When I saw the proof sheet, I was surprised to find detail in places where I couldn't see it originally. Eventually I figured out that the sensitivity of our eyes is limited, but film collects light and amplifies it during a time exposure. By adding more exposure time, shadow detail is increased, dim lights become brighter, and things that are only faintly recognizable may be seen in the final prints or slides.

As an experiment, make some time exposures of a scene illuminated only by streetlights or on a bright moonlit night using a medium-speed film like ISO 100. You can use either color or black-and-white film. Try shooting at 30, 60, and 120 seconds at f/5.6 and f/6.3. The 120-second exposure may be closer to a daylight effect with distinct shadows and faint highlights. Color may be somewhat distorted—either brownish, yellowish, or bluish—depending on the film and on the cleanliness of the air. For example, note the full moonlight photograph of the Taj Mahal on page 21. It was exposed for about 1 minute at f/3.5 on ISO 64 slide film. Incidently, programmed exposure modes at night tend to open the lens to its widest aperture, so you're better off with a shutter or aperture preferred mode or manual setting.

Photography at night can sometimes be more exciting and challenging than using a camera in daylight, especially if you enjoy visual surprises. The lights of signs, store displays, streets, automobiles, monuments, ships, and skylines—just to name a few—are often diverse and colorful. Ever since I shot that first snow scene, I've been intrigued by night photography and I always search for the most appealing subjects.

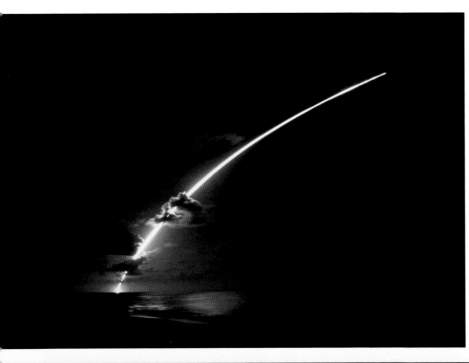

Kathleen Jaeger lives in Melbourne Beach, Florida, about 40 miles from Cape Kennedy. Having watched daytime space shuttle launches, she was ready with a 28mm lens on her SLR when she heard the shuttle was taking off at night. She exposed for about 2 minutes at f/2.8 on Ektachrome 100. Light from burning liquid oxygen illuminated the clouds nicely.

Fireworks flared into star shapes in this 2 second exposure by Jim Jacobs of a church in Mexico. He used a tripod and, exposing by camera meter on Ektachrome 64, he shot half a dozen frames. Jim was surprised to see the greenish tint to the church caused by light sources deficient in red at one end of the spectrum. Interesting things happen at night with daylight color films.

DETERMINING EXPOSURE

While most camera manufacturers incorporate automatic time exposures into their SLR models, it always helps to get a general idea of exposure times for photography at night. Currently the best known SLRs offer automatic exposure up to around 30 seconds. But is this long enough for the low light levels at night? Can you shoot a city skyline, for example, with a 30-second exposure? The answer is yes, depending on film speed and the aperture setting. Before I discuss this, let me first give you some general information about shooting skylines at night. With Kodachrome 64 film, try $f/5.6$, $f/6.3$, or $f/8$, depending on scene brightness, for 12 to 18 seconds. I often start with a 16-second exposure at $f/6.3$, but I may use $f/5.6$ or $f/8$ and vary exposure time as well. Exposure for brightly lit buildings and signs that are close may be about 8 to 10 seconds at $f/6.3$ with the same film. You can adapt these recommendations for the film speed you use, by roughly dividing exposures in half for ISO 100 film and then in half again for ISO 200 film.

Because modern films are now faster, with less grain and more saturated color, in many situations you can make successful handheld night time exposures at ISO 400, 1000, or 1600. I'm stuck on Kodachrome 64 and like the results when I use a tripod, but I switch to faster slide or color print film when I want to shoot handheld exposures or under dim conditions at night. Remember that the smaller the f-stop, the greater the depth of field; so choose an aperture to get the pictorial effect you want, and match the shutter speed, film speed, and lens focal length, with or without a tripod. You also have the option of switching to a faster lens in the

Kathleen Jaeger was in the Notre Dame cathedral in Paris and saw a line of candles gleaming against a dark background. "I had no tripod," she recalls, "so I took a reading with the camera meter and shot on Ektachrome 100 at 1/15 sec. with the 50mm f/1.8 lens almost wide open. I took four frames and noticed later there was an unexpected hand in this one at bottom left that was hard to see."

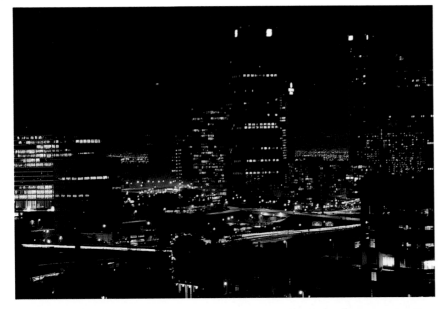

My late wife Barbara and I scouted some hilly areas above Los Angeles looking for a spot to photograph the downtown area. We found a point overlooking the elevated freeways and office buildings that Barbara shot with a 200mm lens on her SLR. With Kodachrome 64 she exposed about 16 seconds at f/6.3. A pattern of lights defines the city and highways while the other details are faint. This is expected when the exposure is set for the highlights.

One summer in Santa Fe, New Mexico, I shot a series of 1/2-second and one-second exposures on Kodachrome 64 with a 70-150mm zoom lens, hoping to get people sharp enough; but this was the only frame that worked. The others were marred by blurry people who seemed to distort the scene as I saw it. The warm incandescent light contrasted well with the greenish tint from the streetlamp.

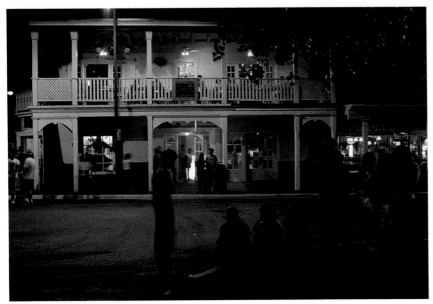

28mm to 50mm range for the increased apertures available. With longer lenses you would probably be more comfortable using a tripod.

Automatic exposure systems seem to work very well at night. Learn to trust yours but know when to compensate for bright or dark subjects. When dark areas predominate, remember to decrease exposure so lights and bright spots don't wash out. For time exposures without automation, set the shutter on "B" and use a locking cable release for less camera shake. Use a watch or count the seconds for exposure. You don't have to be perfectly accurate because the difference between 12 and 10 second exposures is minimal. We're used to fractional shutter speeds, but going from 15 to 20 seconds is only one-third stop more.

A technical footnote: Exposures of more than 20 or 30 seconds can cause reciprocity failure with some films. This means that the film may be unable to compensate for unusually long exposures because not all emulsions are sensitive to light in the same degree. During long exposures a slight color shift may occur because of a chemical reaction. However, films made today seem far less susceptible to reciprocity failure than they were some years ago. Check for reciprocity on the film data. With many films the effect with exposures up to one minute is minimal.

FREEZING OR BLURRING LIGHT

Freezing movement on film at night is not difficult if there is enough light, if the film is fast enough, or if you use a large *f*-stop. On the street or at sports events, you can capture a scene sharply with a handheld camera by choosing a fast film and adjusting your exposure to 1/60 sec. or faster depending on the speed of the action and the *f*-stop you need. An example of how this works is shown here. At the harness race, floodlights were intense enough to permit a 1/250 sec. exposure at *f*/4 on Fujicolor Super HG 1600 print film. Fuji's photographer was positioned with a 28mm lens to show the grandstand and the racers. Had an ISO 400 film been used, the exposure would have been 1/250 sec. at *f*/2, an aperture available in some 35mm and 50mm lenses and a few special longer focal-length lenses. It is evident that an ISO 1600 film was needed here.

Daylight color slide film is preferable to tungsten-balanced film for night pictures in stadiums or sports arenas because the results are warmer and more pleasant. Try daylight film without filters first to see if you like the colors; correction filters cut the film speed in half. Color negative film is ideal because, as mentioned, the color is corrected in processing. Prints can vary though, depending on the lights in the scene and how the processor interprets the filter data. Ask for reprints from color negatives if you're not satisfied at first.

Light paths from moving cars are also a popular after-dark subject. Your shutter speed determines the length of the blurred-light path along with the speed of the vehicle. In one of these matching freeway photographs by Lewis Portnoy, headlights indicate an exposure of about 5 seconds. This was taken at dusk, before the sign was illuminated, when there was more ambient light. In the other picture, a continuous path of headlights and tail lights suggests an exposure of 15 seconds or longer. Night had fallen and all existing light was artificial except the background sky light collected by the film. The aperture was about *f*/5.6, and Portnoy used Kodachrome 25 for each shot. Usually you need a tripod for night exposures of light paths and blurs, but don't always choose a fast film. A slower film gives you the option of longer exposures and longer light paths or more intentional blur. If you do use a film in the ISO 400-1600 range, just stop the lens down farther to get exposures long enough for strong lighting effects.

This detailed photograph was made on Fujicolor print film rated at ISO 1600, which made stopping action feasible in available light. It was reproduced here from a remarkably fine-grained 8 x 10 print supplied by Fuji, Inc.

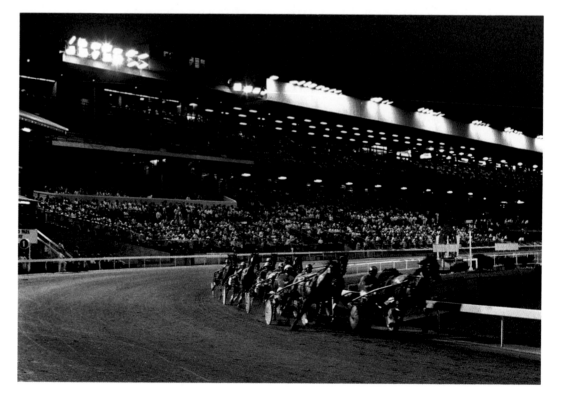

AVAILABLE LIGHT PHOTOGRAPHY

Notice the pattern of cars inching along during Lewis Portnoy's exposure of a few seconds. This picture is subtle because of its low contrast, something that makes effective images more difficult to get than normal- or high-contrast situations. Portnoy made a series of exposures—from 1/8 sec. to 1 minute—as the light dimmed, using Kodachrome 25 film. A few minutes later, the mileage sign was illuminated and all the car headlights were on for a longer, brighter exposure. Lew didn't move his camera, but the falling level of light helped to create quite a different picture. In the shot below, exposure was about 15 seconds.

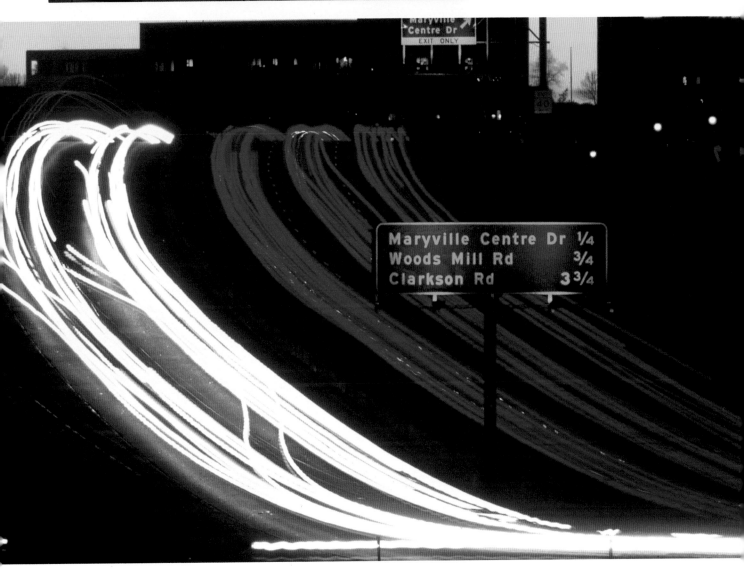

Although Lewis
Portnoy shoots scenics
and many other
subjects, he is a sports
specialist. To freeze
the action of a St.
Louis Cardinal pitcher
during a night game,
he stood behind home
plate with an F2.8
400mm lens and shot
at 1/500 sec. at
f/2.8 on Fuji 1600
film. "In almost all
stadiums you can use
daylight slide films,"
Lew comments.
"Kodachrome 64 and
200 and Fujicolor
1600 are my favorite
films, and I rate the
Fuji everywhere from
ISO 400 to 1600
depending on the level
of the light."

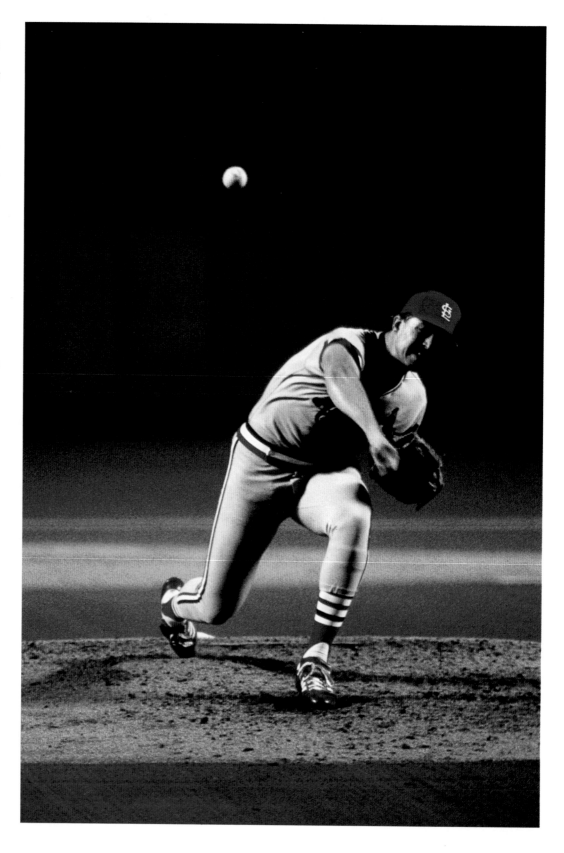

AVAILABLE LIGHT PHOTOGRAPHY

CREATING PATTERNS WITH LIGHT

Until now I've been discussing straight nighttime photography without any tricks or manipulation. Though moving automobile lights can create attractive patterns, you control the exposure interval to influence the kind of pictures you hope to get. Now I'll mention a few special effects that can be accomplished at night with a camera that takes time exposures, either automatic or manual. Exposure suggestions are given for ISO 100 film, but you can convert them for the film you use.

To photograph fireworks you don't always need to use a timed exposure mode. If you choose to use the automatic mode, first set the camera on a tripod and remember that the meter will read the black sky and overexpose; so, make a one-stop compensation on the minus side. For manual exposure, set the shutter on "B" with the aperture at about $f/8$ and expose for 1 or 2 seconds. You may also bracket by adjusting the f-stop in half stops until you are experienced with fireworks. The longer the exposure, the more of an explosive burst you'll catch on film. If you want a series of overlapping explosions on one frame, use "B," stop down to about $f/11$, and leave the shutter open for 6 to 8 seconds. You may also lock the shutter open at $f/11$ and hold your hand or a black card over the lens between bursts, unless your camera has a multiple exposure mode. You can't exactly pick where the flashes will occur, but expect some pleasant visual accidents. You can shoot fireworks by handholding the camera with the shutter wide open—any camera movement merely widens the splashes of light.

Moving the camera while shooting lights can also create some great effects. Point the lens at whatever lights you think are colorful or attractive, and maneuver the camera a foot in any direction during the exposure. At $f/8$ or $f/11$, try a 2 second exposure, but experiment with other intervals and f-stops. The light patterns should be fascinating and unpredictable streaks of color, brightest where there is any overlap. Move the camera slowly and consistently; the wider and faster your movement, the more confusing the pattern may be. Shooting lights this way is a little like abstract painting, but you don't see the combinations until later. Another approach is to zoom the lens during an exposure of a few seconds Try an aperture of $f/5.6$, though exposure will vary with the brightness of the lights you're shooting. Zoom with the camera on a tripod to get straighter lines and better control. With a handheld zoom of more than a few seconds the lines may waver. Try both methods and zoom both forward and backward.

On the 4th of July, I can't resist photographing the fireworks wherever I am. I may shoot handheld pictures for 1 or 2 seconds at an aperture of f/4.5 or f/5.6 or use a tripod for sharper effects. Here the shutter was on "B" and I estimated a 2 second exposure for the large explosion; then I waited with my hand over the lens and caught the smaller spot of light in a 1 second exposure. Locking cable releases are available for many cameras to hold the shutter open with less risk of camera movement.

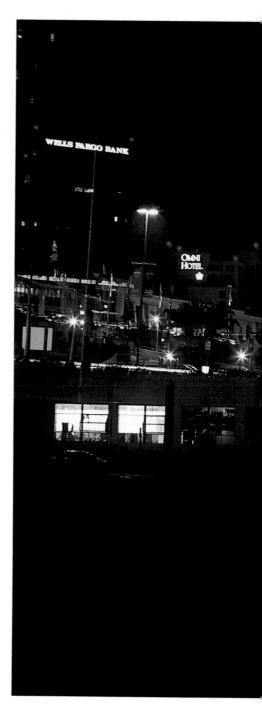

When Barbara Jacobs shot the time exposure of downtown Los Angeles on page 121, she also turned her SLR to a vertical position and slowly zoomed the lens from 80mm to 200mm during a 15-second exposure made at about f/6.3 on Kodachrome 64. Differences in the light streaks were caused as the focal length changed and different subject matter was covered.

AVAILABLE LIGHT PHOTOGRAPHY

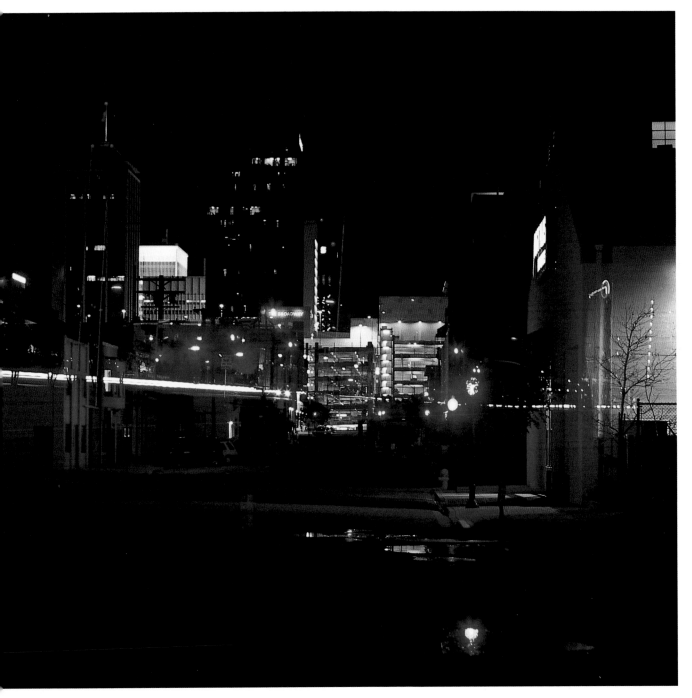

This was a double exposure in downtown San Diego. I made the first exposure on "B" for about 15 sec. at f/8 on Kodachrome 64. I then swiveled the camera with my hand over the open lens and photographed passing traffic and more lights against a black background for 10 more seconds. I did this on several different frames, knowing that the combined exposures might not be successful each time.

SPECIAL CREATIVE EFFECTS

Bud Kennedy of Wichita, Kansas, made 25 to 30 exposures of this setup from several positions and found this backlit one most attractive. It was made on 100 ISO Kodak Varicolor Professional (VPS) film using an SLR with 50mm lens. The exposure was 1/2000 sec. at f/4. With the sun behind the model in late afternoon, the background went dark, obscuring wires, poles, and fences. This picture has won awards in several exhibitions.

DIVERSIFIED COLOR

Most of this book has concentrated on straight photography with a few side roads into exposure zooms and blurred lights at night. Photographers usually try to master basic techniques before they start experimenting, but it is not necessary to learn all the conventional approaches to picture-taking before you try abstractions, multiple-exposures, or other creative effects. It is useful though to have a comfortable knowledge of composition and color. There are books about basic design and courses that might help improve your seeing. It is also enlightening to discuss with other photographers the many ramifications of "what makes a good photograph." Keep in mind that talented and accomplished photographers, painters, and other graphic artists tend to make the visual results of their techniques seem simple. Often though, they're not.

In a quest for more ways to enjoy available light photography, expose yourself to as many photographic exhibits and books as possible. Become familiar with the work of photographers such as Man Ray, Edward Weston, Imogen Cunningham, Duane Michals, Laszlo Moholy-Nagy, Alfred Stieglitz, Pete Turner, Jerry Uelsmann, Harry Callahan, Walker Evans, Wynn Bullock, Eugene Atget, Dorothea Lange, Clarence John Laughlin, and dozens of other imaginative and stimulating artists. When you are at an art museum, browse in the book shop. You'll find unusual and inspiring books about photography in such museums as The Museum of Modern Art and the International Center of Photography in New York, the San Francisco Museum of Modern Art, The Los Angeles County Museum of Art, The Chicago Art Institute, The High Museum in Atlanta, The Dallas Museum of Art, The Denver Art Museum, The Nelson Atkins Museum of Art in Kansas City, The Santa Fe Museum of Art, The California Museum of Photography in Riverside, and the Museum of Photographic Arts in San Diego.

Although many of the the world's best photographers have worked in black-and-white, there are plenty who work and experiment in color. The term "diversified color" refers to incongruities of form and color that diverge from the conventional. Look for offbeat lights, signs, colors, shapes, reflections, or relationships to photograph and explore their decorative effects.

The first few times you try something different, you may be disappointed, but keep trying. Keep looking at reality from your own angle. If color isn't as askew as you would like it to be, give it your own twist with a filter. Accent a sunset with added gold or use a use a blue filter on a rainy day for an extra chilly appearance. Consider a fog filter, star filter, or a red filter at dusk. Filter manufacturers like Tiffin, Hoya, Cokin, or Spiratone have brochures showing how their products can creatively alter the real world. You may tint colors, make overlapping double exposures, or refract lights into spectrums according to your own taste. Creativity can help make images others haven't been able to see. Remember though, it is not the filter that makes a creative and memorable image; it is the way you saw it in the first place. Try to sharpen your skills of "seeing" the photograph before you take it.

At an exhibit, an artist had built a set of colored panels against which members of the audience were supposed to see each other in different ways. This kind of special effect is easy to photograph but hard to find. I used a 50mm lens on an SLR for a handheld exposure on Kodachrome 64 film.

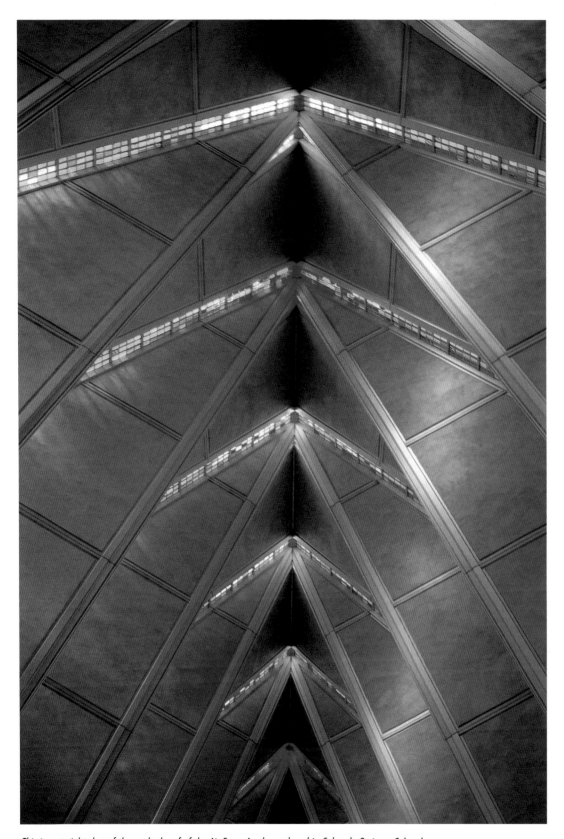

*This is a straight shot of the vaulted roof of the Air Force Academy chapel in Colorado Springs, Colorado.
Bud Kennedy was attracted by its luminosity and photographed it on Kodachrome 64 (rated at ISO 80 for
better color saturation), handheld at 1/15 sec with an F2.8 lens on his SLR.*

SPECIAL CREATIVE EFFECTS

CREATIVE BLURS

Some blurred photographs are thrown away because the picture is confusing and could never be passed off as creative. But some images seem to have more of an impact when they are blurred deliberately or the subject moves delightfully. The basis of photographic blur is a slow shutter speed under your pictorial control. You compose the image and choose the right lens and shutter speed; the rest is up to the movement of the subject. To some extent, experience does help to guide the outcome of the unexpected. Plan to shoot a roll of film at slow shutter speeds and keep notes. Try moving your camera when it is pointed at a night scene. Focus on running water or moving lights, and control the amount of blur by choice of shutter speeds. Photograph people in motion at night or in low light levels; for instance in a shopping mall or on a city street.

Through experiment you'll develop an instinct about how much blur to expect in various circumstances from shutter speeds between 1/30 to 2 seconds. Work with the longer exposures, but remember that you can lose the subject entirely at a slow speed in a complete blur. At the other extreme, I feel that speeds faster than 1/15 sec. can stop enough action so that pictures look like blurred mistakes. If I'm handholding an SLR, the slow speed I choose depends on the brightness of the light and subject movement.

It is feasible to shoot at slow shutter speeds with any film, but you should choose a film in the ISO 25 to 100 range to give you more latitude in daylight or dusk exposures. I've made intentional blurs in shade, at the end of the day, and at night with Kodachrome 64. It usually doesn't matter what aperture you shoot at because depth of field isn't a factor when little or nothing in the scene is sharp. In bright daylight though, you'll have to slow down the shutter speed even more and stop down the aperture (to *f*/16 or *f*/22 if available) to avoid overexposure. Another route is to use a neutral-density (ND) filter rated 2X or 4X. An ND filter is neutral gray, doesn't affect color, and cuts film speed in half (2X) or down to one-fourth normal speed (4X). Thus an ISO 100 film becomes ISO 50 with a 2X ND filter and ISO 25 with a 4X ND filter. You'll need to use an ND filter in daylight for zoom-during-exposure pictures.

Panning the camera is really a useful special effect. Panning means to follow a subject moving

Experimenting with impressionistic techniques, Jay Maisel used Kodachrome 25, stopped his lens down to f/22, and exposed at 1/2 sec. while moving the camera slightly in the direction of the lines seen. He shot many frames but because he first conceptualized the painterly effect he wanted, he was successful.

SPECIAL CREATIVE EFFECTS

across the film plane by pivoting the camera at a pace that keeps the subject in the viewfinder from one point to another during a single exposure. The illusion of motion is created by a streaked background while the main subject is still somewhat sharp. You can pan with your camera on a tripod or handheld. Aim and focus the lens at the moving subject before it reaches the area where you plan to shoot. As the subject whizzes by, follow it by turning your whole torso or the tripod head, and snap the picture midway in your turn. But don't stop moving when you release the shutter. Your follow-through (much like a good golf swing) after the shutter has fired helps create the graceful streaks you see behind the relatively sharp image of the main subject.

Panning takes some practice before you know when to start, when to shoot, and how to follow-through. Also important are the shutter speed and film you choose. A film in the ISO 25 to 100 range is preferable because you need a relatively slow shutter speed such as 1/30 or 1/60 sec. in order to get those background streaks. Try shooting even at 1/15 sec. as you practice panning. You can shoot action at such slow speeds because the camera's movement should be synchronized with the subject's movement. As your panning technique improves, the sharper the main image will be.

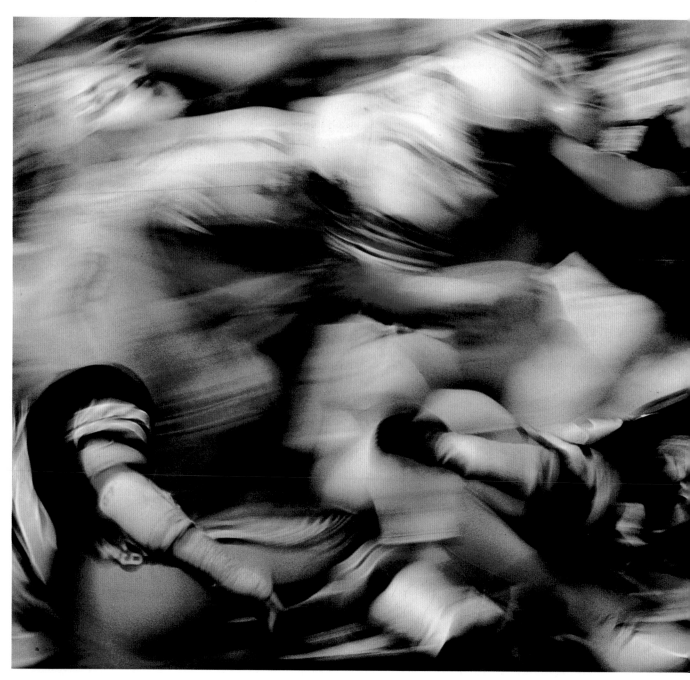

AVAILABLE LIGHT PHOTOGRAPHY

As an aid to panning with faster films and to shooting zoom-during-exposure pictures in daytime, remember to use ND filters. Zoom exposures require even slower shutter speeds than panning (around 1/2 to 1 second). Just aim the camera at the action or subject, set the lens at its closest or farthest focal length, press the shutter release, and zoom the lens as smoothly as possible during the exposure. You can either handhold the camera or shoot from a tripod for more stability. It takes practice to discover how timing and zoom direction will affect your pictures. Even an experienced pro can't predict with certainty what the final effect will be with each picture, so shoot a number of variations.

Zoom exposures are better made in bright shade than in bright sun to avoid overexposure. With an ISO 50 film and bright sun, a 1/125 sec. at f/6.3 exposure would, with a 4X ND filter, become 1/2 sec. at f/16 or 1 second at f/22. In a pinch you can use a 2X and a 4X ND filter together, though sharpness is affected when you combine two filters. With a film in the ISO 100 to 200 range, daytime zoom exposures may be feasible only at dusk or in brighter light with a very slow film and ND filters. Blurred and panned action is mostly unpredictable, and the challenge is fun. Experiment with a tripod and a series of shutter speeds to see what happens. Even if all you learn is what not to do, the film won't be wasted.

Lewis Portnoy turned his camera on part of the crowd in the grandstand on a cloudy day and zoomed his 80-200mm lens using Kodachrome 64 film. "I may have shot at 1/8 sec. or 1/4 sec.," Lew says, "because I try several slow exposures to vary my zoom effects. Experimenting with organized zoom blurring adds excitement to the pictures I shoot at a sports event."

About the football scene on the left, Lew says, "I shoot Kodachrome 64 at 1/15 sec., often with a 300mm F/2.8 lens. There's a strong feeling of action and even menace in blurred pictures and if I'm doing a commercial job, I avoid having to get model releases." Lew handholds his SLR and only uses a tripod when his blurred exposures are longer than 1/15 sec.

Lew Portnoy made this blurred and panned photograph at a track meet in Los Angeles. "For blurred shots in bright daylight, I almost always use a 2X-or-stronger ND filter," he explains. "Then I can shoot at 1/15 sec. for a little blur in human subjects and at higher shutter speeds for race cars or planes." Note that the running figures vary in sharpness according to their action while Lew's panning shutter was open. The film was Kodachrome 64.

On the right, Bill Stahl used a 200mm zoom lens on Kodachrome 64, though he may use Kodachrome 25 on a bright day. He panned a passing race car, following it across the film plane, shooting at 1/30 sec. on Kodachrome 64. He shoots at 1/15 sec., 1/30 sec., or 1/60 sec. depending on how much blur he wants to achieve. "I like the blurred and sharp combination," he says, "because it gives the illusion of speed." Bill says he enjoys using zooms because there is less equipment to carry and adds, "I'm unable to see any difference in picture sharpness or contrast at 8X magnification between fixed-focal-length lenses and zooms."

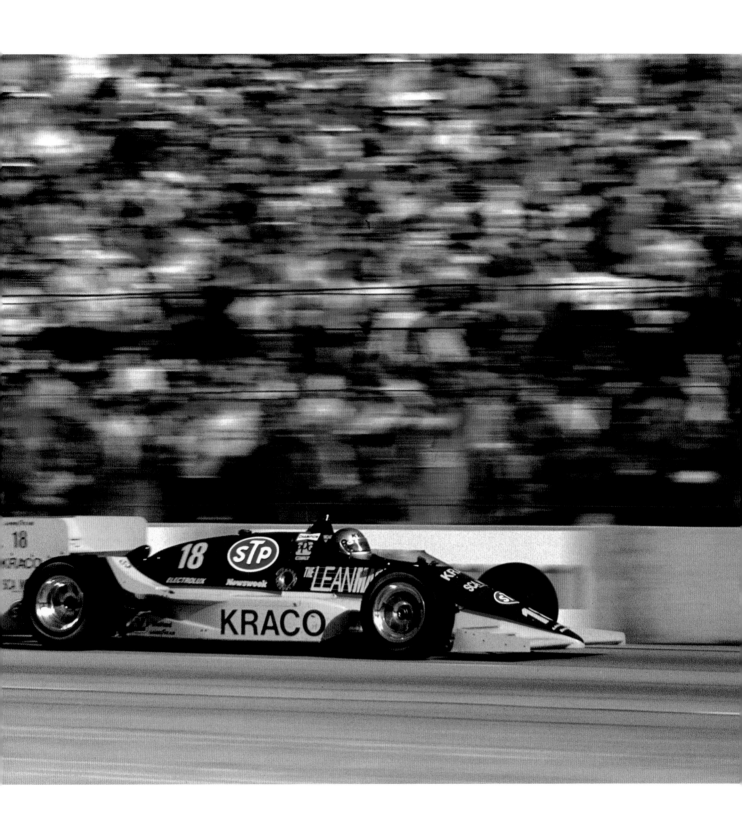

MULTIPLE EXPOSURES

Light patterns, either taken from a tripod or shot handheld with a moving camera, can make for some interesting pictures when combined with other subjects. Spend some time checking your slide files. By careful picture editing, you may find two slides that make a better image sandwiched together than either of them does alone. But then again, you can always shoot with this process in mind. If you do, overexpose the slides by one-third stop so the density of the combined image will be

Scott Mutter skillfully combined three negatives to create this image of a man wading through surf on his way to a massive escalator.

normal. Place possible sandwich slides atop each other, and study them for composition, color, and contrast. If you find a pair that work together, put them both in one slide mount. The work may be worth the reward.

Multiple exposures made in the camera can be either precise or casual. With the more casual technique, you should try to experiment as much as possible, exposing images on top of one another. With this technique though, you are never really certain how the image will come out. Ideally, you try to overlay light and dark areas for contrast and an enjoyable mix of colors; and, at the same time avoiding excess confusion in the total image. For an in-camera multiple image, divide the total exposure time for each image by the number of shots you are taking. For instance, if you combine two images and the normal exposure for each is 1/125 sec. at *f*/11, shoot each instead at 1/250 sec. at *f*/11 or 1/125 sec. at *f*/16. By dividing the usual exposure, the combined image will be exposed normally.

To be more precise in making multiple exposures, use either a large-format camera or a camera with a multiple-exposure button. As an example, from a vantage point above a section of a town, set your camera on a tripod and choose the composition you wish to photograph. The purpose is to shoot the scene with sunset colors, then shoot it again after dark when the lights in the city are on. The combined image will have that extra drama that might be needed. You can use either a view camera, or one that has a multiple-exposure setting; but, be sure not to move the camera even one millimeter or the image will not be in perfect register. When you experiment with multiple exposures, try to anticipate where each image will fall in the format and try to overlay light and dark areas for contrast and color blends.

Another way to plan a multiple exposure is to print it in the darkroom with two or more negatives. Scott Mutter of Chicago creates impressive photomontages like the one on the left. "I did this with three separate negatives," Scott says. "First I printed the escalator, then masking it off and feathering the bottom edge, I printed the surf, which happens to be Lake Michigan. Finally I overlaid the dark figure, dodging around it as I printed."

Sonja Bullaty first photographed herself and husband Angelo Lomeo standing quietly with some cars behind them. She then found a nearby florist's window that she exposed on the same frame of Kodachrome using the camera's multi-exposure mode. The result is intriguing and mysterious. The figures are obscured by reflections and colorful flowers, but the design is delightful so you don't care if it is fully realistic or not. Sonja planned the combination in her mind and used an SLR on a tripod and self-timer.

Through careful picture selection, you may find two slides that sandwiched together in one mount make a better image than either of them does alone. When you shoot pictures specifically to sandwich them, remember to overexpose each image by about one-third to one-half stop so the combined picture will have normal density. Light patterns make interesting combinations with other subjects. This image was made by combining a picture of blurred lights, taken by moving the camera during the exposure, with a daytime shot taken on a large ferry boat. To check potential sandwich photographs, place slides on top of each other and study them. When you find a pair that work together, the search is worth the effort.

SPECIAL CREATIVE EFFECTS

EXPERIMENTING WITH FILM

There are a number of other unusual processes in photography. Some are simple, such as hand-tinting prints, or shooting through a Spiratone zoom filter, which preserves the center of the image sharply, but allows the zoom to blur the rest of the scene. There are too many ways to manipulate and alter available light pictures to show them all here, so I've chosen just a few approaches to show here.

Infrared photography can be used to produce some fascinating surreal images in both color and black and white. Making color infrared photographs is somewhat tricky and it is difficult sometimes to locate infrared film. Kodak Ektachrome 35mm color infrared film comes with no prescribed ISO rating, but Bernard Lynch, Jr., whose photographs are shown here, sets it at ISO 200 for his tests. According to Lynch, infrared film is usually shot with color filters; either deep green, deep yellow, or even purple. Exposure is based on trial and error because meters don't register infrared wavelengths. The film doesn't react in a conventional manner, and there is a tendency for extremes of contrast. In addition, focus is at the infrared mark that is slightly off the regular focus point.

Konica also makes color infrared film, but only in the 120 format. Kodak produces a 35mm black-and-white, high-speed infrared film that is more readily available than the color films. Again, according to Lynch, the ISO speed for the black-and-white film depends on what you are actually shooting. You also need a filter, usually the R25 red filter, to get the full effect of the properties of infrared. You have to compensate for the added filter and cut the ISO speed at least in half. In most cases your exposure meter is worthless because the film is sensitive to reflective radiation rather than visible light. You'll find that grass and leaves appear very light in the pictures, while the sky is usually much darker.

Posterizing is another way to alter available light photographs, as shown in the pictures on pages 142-3 made by Bill Stahl via the LaserColor process offered by LaserColor Laboratories in West Palm Beach, Florida. After the film is processed, the slide or negative is scanned at the laboratory and transferred into a computer. Then the colors and shapes in the original image can be manipulated to the desired effect, be it swirls of color, repetition, or color distortions.

Let your imagination flow as you discover new avenues in available light picture-taking and enjoy them endlessly. At the same time or as an adjunct to the usual, play with whatever indirect or otherwise satisfying approaches you like. Look for nature's quirks and abberations. Try self-portraits on your own terms. Photography is an art, a science, a skill, and a wonderful path to personal pleasure, and I wish you many, many hours of enjoyment with your camera in whatever light you may find yourself.

Color infrared photographs, such as this one taken in a graveyard, are tricky according to Bernard Lynch Jr., who has been shooting them for many years. Ektachrome infrared film comes with no prescribed ISO rating; he used ISO 200 for his tests. "You shoot with color filters," he explains, "with deep green, deep yellow, or even deep purple. My best and strangest results seem to come from the yellow filter. Exposure is based on trial and error. Half a stop over and the slide may be washed out, but half a stop under will be okay. The film doesn't react in a conventional manner, and there is a tendency for extremes of contrast. Personal testing is essential. Good starting points for full sunlight may be plus or minus one stop in the f/5.6 to f/8 range. I use 1/60 sec. or 1/125 sec. depending on light variations and the subject. I think this was taken at 1/60 sec. at f/8. The film is developed by the old E-4 process, and you have to find a lab that does it. You also have to find subjects that respond well to infrared color film."

Kodak also makes black-and-white infrared film that Bernard Lynch Jr. used for these two photographs. "One needs to rate the ISO speed according to how and what you're photographing," he explains. "I shoot black-and-white infrared in direct sun with well-defined shadows at ISO 400 using an R25 red filter. You need the red filter to fully realize the properties of black-and-white infrared film. You can also try a polarizer in conjunction with the R25, which gives you some margin for in-camera image tone manipulation. You have to compensate for the added filter and cut the ISO speed, at least in half. In most cases, your exposure meter is worthless because the film is sensitive to reflective radiation rather than visible light. With a red filter, I can shoot in direct sun at 1/60 sec. at f/11, but I must bracket. Half-stops are fine. The self-portrait was taken at 1/60 sec. and f/16. The blocked-up white tone is part of the infrared mystique. Use the small dot or line to the right of the normal focus line on your lens to focus with black-and-white infrared film. The image will be in focus on the film, but perhaps not to the naked eye." Kodak has literature about infrared photography that you can find in camera shops.

AVAILABLE LIGHT PHOTOGRAPHY

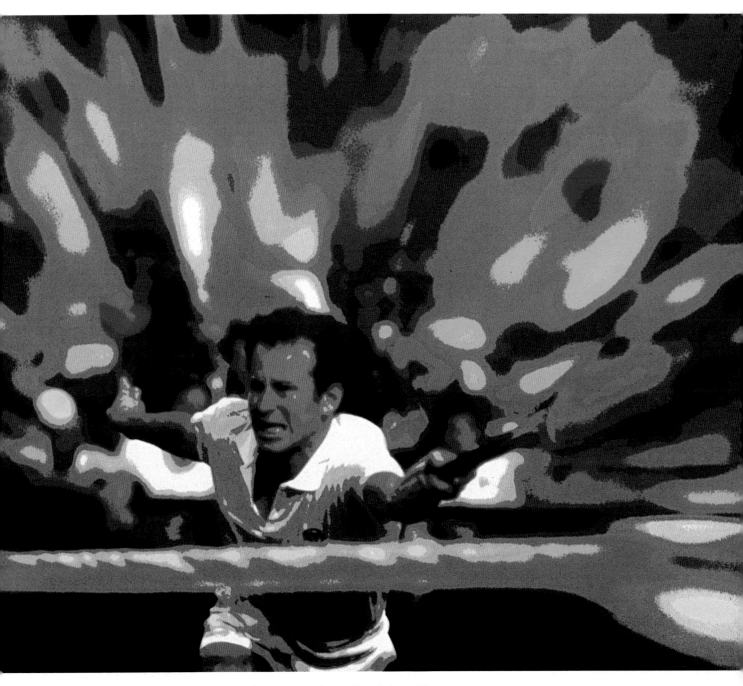

Bill Stahl photographed John McEnroe playing tennis for a magazine client and later had LaserColor Laboratories in West Palm Beach, Florida, scan the slide with a laser that translated the image into a computer, where the result was exposed to negative film. A number of artistic effects are possible in the laser process by using a wide palette of colors based on the original image. Stahl tells the lab what he wants, and the staff knows through experience working with him how abstract or literal to make the laser image. Prints are also available by the same process. Bill does both advertising and editorial work, specializing in sports action.

Bill started photographing automotive racing in 1965, and today he has clients around the world who like his colorful images of cars and their drivers in action. He shot the original of this closeup on the left with a 70-210mm zoom lens and then duped it by shooting through a cone of reflective mylar that eliminated some of the undesirable background. The dupe slide was then scanned by LaserColor Laboratories.

INDEX